Jennifer Steinkamp: Blind Eye

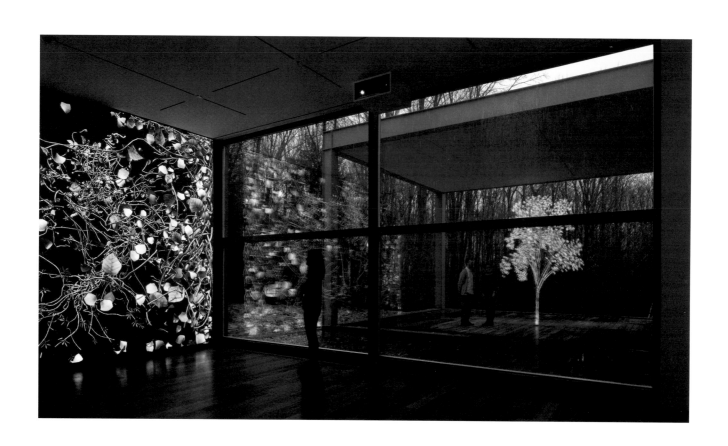

Jennifer Steinkamp: Blind Eye

With an essay by Lisa Saltzman

Principal photography by James Ewing

Clark Art Institute, Williamstown, Massachusetts

Distributed by Yale University Press, New Haven and London

Jennifer Steinkamp: Blind Eye

Foreword

Jennifer Steinkamp's twisting animations and undulating virtual abstractions activate the walls of the Clark Art Institute's galleries on Stone Hill during the summer of 2018. Her work transforms the Lunder Center's imposing yet serene architecture into artificial forests that evoke the trees covering the Clark's campus. Simultaneously disorienting and tranquil, the colorful moving images add texture and light to the stately Tadao Ando–designed concrete structure. Like living wallpaper, or tapestries woven from code—obviously simulated and yet full of natural forms—Steinkamp's video projections resist classification.

As we commemorate the tenth anniversary of the Lunder Center at Stone Hill this year, we reflect on the relationship between art and nature—one that was vital to Sterling and Francine Clark, and an essential part of the decision to situate their world-renowned art collection in Williamstown. The works chosen for this exhibition reflect a careful consideration of the importance of our landscape, and, indeed, Steinkamp's installations engage with the Clark's unique environment. In Steinkamp's new, site-specific piece titled *Blind Eye*, she features the white and gray birches that surround the Lunder Center and line the wooded paths up to Stone Hill. This mirroring of the natural environment within the galleries marks a celebration of the site and its distinctive offerings, while welcoming a decade of outstanding exhibitions to come.

This is our inaugural exhibition of contemporary video installations, and with it, visitors are encouraged to contemplate the passage of time in the continually looping projections. This show encapsulates the development of Steinkamp's career over the past three decades as she continues to alter perceptions of architecture and space through the use of technology.

At the Clark, credit goes to Esther Bell, the Robert and Martha Berman Lipp Senior Curator and curator of painting and sculpture; Kathleen M. Morris, the Sylvia and Leonard Marx Director of Exhibitions and Collections and curator of decorative arts; and Regina Noto, curatorial assistant, for their expertise and organization of diverse aspects of the installation. We are also grateful to Lisa Saltzman, Starr Director of the Clark's Research and Academic Program, for her insightful essay, which explores structuring concerns in Steinkamp's oeuvre. Most especially, we thank Jennifer Steinkamp for generously sharing her art with us, creating a new piece inspired by the Clark and our campus, and filling the Lunder Center with her riveting interpretations of nature. In turn, Steinkamp extends her appreciation to her team, including Dino Xiaojun Zhang and Kate Hollenbach, and, from Lehmann Maupin, Jennifer Mora.

I am deeply obliged to our friends and sponsors for their generous contributions in support of this project, and, in particular, would like to thank Clark trustee Maureen Fennessy Bousa and her husband Edward P. Bousa, and trustee Amy Scharf and her husband Charlie Scharf for their incredible commitment to this exhibition.

Olivier Meslay
Hardymon Director

Back to the Garden: On Gender, Genre, and the Virtual Worlds of Jennifer Steinkamp

Lisa Saltzman

LET THERE BE LIGHT

On a crisp, clear early December evening, I headed down Philadelphia's Benjamin Franklin Parkway, eager to see the new public art installation by Jennifer Steinkamp, *Winter Fountains* (2017). The second in a series of projects commissioned by the Association for Public Art (aPA) to mark the centennial celebration of the parkway, Steinkamp's *Winter Fountains* at once introduced Philadelphia to her singular artistic vision and honored the city's early history as a site of scientific inquiry and experimentation.

In the months just prior, the contemporary Chinese artist Cai Guo-Qiang had transformed the city's central civic artery into an enormous stage, envisaging and realizing a participatory performance piece as athletic as it was balletic. Each evening during the run of Cai's piece *(Fireflies)*, rickshaws rigged with playful, bobbing lanterns plied their trade, transporting the city's denizens and tourists along the parkway's freshly painted bicycle lanes. With cars and pedicabs moving up and down the parkway at different speeds, their lights moved in and out of sync, periodically aligning and then diverging to produce a luminous contrapuntal rhythm. Steinkamp took a different tack, although her installation also brought light and motion to the city's parkway.

Over a period of days in the month leading up to the unveiling, four monumental hemispheres had taken up residence on the grassy shoulders and pocket parks along the majestic route that runs from City Hall to the Philadelphia Museum of Art, a roadway flanked by many of the city's most important cultural institutions. Thirteen feet high and twenty-six feet wide, the provenance and purpose of the 4,500-pound fiberglass domes remained a tantalizing mystery. Penned behind chain-link fencing, at once captive and captivating, their hulking presence belatedly dramatized all that was implied and critiqued a half century earlier in Michael Fried's canonical essay "Art and Objecthood."[1] Then finally, on the last day of November, the fencing came down, and with the setting of the sun, the glittering white forms came to life as giant cinematic screens, each illuminated and animated by a set of four carefully calibrated projectors.

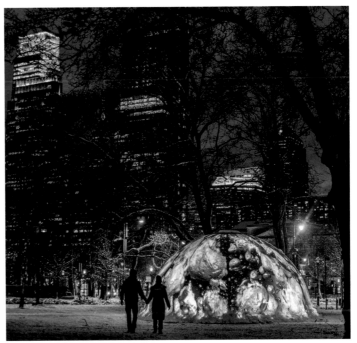

Fig. 1a: Jennifer Steinkamp (American, b. 1958), *Winter Fountains*, 2017. Video installation (video projected on molded fiberglass embedded with glitter), Benjamin Franklin Parkway, Philadelphia, four domes, 13 x 26 ft. diam. (3.96 x 7.92 m diam.) each. Photo by Meredith Edlow, courtesy Association for Public Art (aPA)

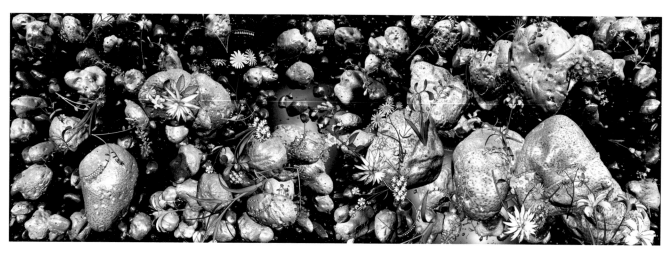

Fig. 1b: Jennifer Steinkamp, *Winter Fountains* (detail), 2017

Enigmatic igloos by day, inverted planetaria by night, each glowing orb offered an illusionistic antidote to the mid-Atlantic winter's icy grip (fig. 1a). In contrast to the grand, figurative sculptures circulating sprays of water from their standing pools that also adorn the parkway, Steinkamp's massive, minimalist monoliths melted into a perpetually looping cycle of computer-generated animations. Variously bathed in shifting hues of pink, green, yellow, and blue, the fountains poured forth a dazzling three-dimensional display, the gelid waters of winter thawing in a phantasmagoria of fluid dynamics (fig. 1b). On scales at once macro-

and microcosmic, the filmic *Winter Fountains* featured a drama of particles in motion, their erratic paths periodically brightened by bursts of distant light and vivid bolts of lightning and then enveloped in emerging scrims of gently falling flowers. Conjuring both the collision of asteroids at the far reaches of the universe and the knocking of subatomic quarks or protons in a physicist's laboratory, Steinkamp's *Winter Fountains* dramatized the primordial processes by which electricity and energy are created.

Given its realization as a commemorative commission, the piece was, at its most literal, also something of an ode to Benjamin Franklin's variously apocryphal and actual experiments with lightning and static electricity. But even had there not been that specific impetus, Steinkamp's installation took shape against the broader backdrop of Philadelphia's singular place in the history of a young nation, attentive to its role as a cradle of early American civilization and a crucible of scientific innovation. In conceiving her luminous site-specific project, Steinkamp explored and mined the city's many archives and museums, all the while remaining attentive to the majestic monuments and civic architecture along the parkway. In turn, she designed a multifocal piece that was expressly responsive to Philadelphia's unique history, from Franklin's experiments to John Bartram's botanical garden, as well as to its location along the Benjamin Franklin Parkway. Philadelphia's most Parisian of avenues, specifically designed to emulate the Champs-Élysées, the boulevard is anchored not by triumphal arches but by allegorical fountains. To the west, on the northwestern edge of Eakins Oval, rises the Washington Monument fountain (1897), and at its midpoint, in the center of Logan Circle, sits the more playful Swann Memorial Fountain (1924), also known as the Fountain of the Three Rivers.

Winter Fountains made these contexts available to its viewers, imaginatively and allusively conjuring elements of a nascent nation's scientific contributions even as it celebrated the legacy of an urban planner's transatlantic vision. But as much

as *Winter Fountains* was inspired by that national history and tethered to the city that was its temporary site, its conceptual and temporal reach is more expansive. Despite its connection to Franklin and Philadelphia, its iconographic program displays and distills a set of concerns that have defined Steinkamp's work for nearly three decades. Science may be her subject here. But it is science fiction that is her frequent muse. Similarly, while history may provide the impulse for *Winter Fountains*, myth and fantasy fuel Steinkamp's imagination. And ultimately, the celestial gardens of stones may also offer up a declaration of self, an oblique sort of self-portrait: for Steinkamp's surname carries with it from its Germanic origins the rocky enclosure in which her ancestors may once have dwelt.

Following directly on *Winter Fountains*, the exhibition in the Lunder Center at Stone Hill at the Clark Art Institute organizes an extraordinary encounter with Steinkamp's work and affords viewers an opportunity to contemplate her innovative practice. Individually and collectively, the pieces projected on the gallery walls—*Premature*, 6; *Rapunzel*, 5; *Fly to Mars*, 6 and 9; *Diaspore*, 2; and *Blind Eye*, 1—provide a remarkable compendium of the thematic concerns and structuring techniques that have animated her work since its very beginnings and continue to shape her practice in the present. A virtual greenhouse of gently swaying trees, blowing tumbleweeds, peeling bark, and snaking chains of flowers, the installation intensifies our encounter with the landscape that is part and parcel of any visit to the Clark. But even more, as gallery wall gives way to cinematic screen, as foliage and flowers shift and sway in serpentine rhythms, the museum and grounds come together in an immersive experience that is nothing short of transcendent, leading us back to the Ur-garden—that garden of earthly delights that, at least within the Judeo-Christian context, we know as Eden.

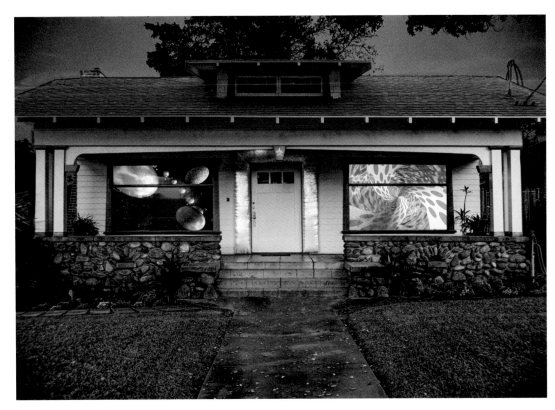

Fig. 2: Jennifer Steinkamp, *Gender Specific*, 1989. Video installation, Bliss House, Pasadena, California, each 6 x 8 ft. (1.83 x 2.44 m)

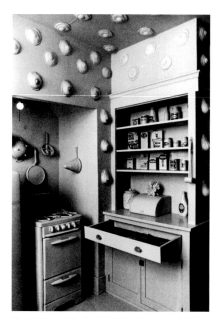

Fig. 3: Susan Frazier, Vicki Hodgetts, and Robin Weltsch, *Nurturant Kitchen*, 1972. Mixed media, installation in *Womanhouse*, Los Angeles (January 30–February 28, 1972), organized by Judy Chicago and Miriam Schapiro. California Institute of Art Archives: Feminist Art Materials Collection

GENESIS

Since the late 1980s, Steinkamp has been experimenting with digital animation to generate and project the illusion of three-dimensional motion. Drawing on innovations in computer-generated imagery (CGI) and refining their imagistic possibilities for her purposes, Steinkamp has produced a body of digital work that deploys video projection to transform architectural surfaces into abstract visual fields and hyperrealist virtual worlds. Indebted as much to her professional experience in commercial industry as to the lessons of her art school training, Steinkamp has mined and manipulated the most advanced algorithms to create a remarkable range of luminous installations.

Her first public installation, *Gender Specific* (1989), established a set of aesthetic practices and thematic concerns and also augured much of what would follow in the ensuing decades of her artistic career. When *Gender Specific* debuted simultaneously at both the Santa Monica Museum of Art and Bliss House in Pasadena (fig. 2), Steinkamp had only just begun to make her mark as an artist. Shortly before, she presented *Rationality vs. Conventionality* at EZTV Gallery in Hollywood. A slide show of sexist phrases, the now legendary work was inspired as much by Ed Ruscha in its pictorial materialization of language as by Barbara Kruger and Jenny Holzer in its overt political

message. In turn, even as *Gender Specific* manifested a broader set of artistic lineages, from the phenomenological imperatives of the West Coast practitioners of minimalism and the singularly Southern Californian aesthetics of the Light and Space movement to the structural and technical inheritance of both experimental structural cinema and abstract commercial animation, the dual-sited 1989 installation maintained and furthered the feminist ambitions of that inaugural student endeavor.

Doubling and dividing the site of artistic display by utilizing two locations—one, a new Frank Gehry–designed contemporary art space in a refashioned warehouse on the city's west side, the other, a student-run gallery in a modest craftsman bungalow in Pasadena to the east—Steinkamp's *Gender Specific* introduced a novel logic into the exhibition equation. For even in a movie town like Los Angeles, where multiple crosstown screenings of a new film are the order of the day, to have two simultaneous "showings" of an exhibition was to reimagine the conventions of the gallery system, upending practices both commercial and cultural. But this was only one of its many challenges and innovations. Perhaps most crucial to establishing its critical credentials, Steinkamp's *Gender Specific* also reimagined for its postmodern present Judy Chicago and Miriam Schapiro's collaborative celebration and proclamation of feminist practice and principles, *Womanhouse* (1971–72; fig. 3).

Where the expressly essentialist sculptural interventions of the early 1970s *Womanhouse* reclaimed and rescripted an already feminized domestic space as a wholly political site of encounter, the late 1980s *Gender Specific* launched a very different sort of aesthetic intervention into the built environment, treating both sites as opportunities for deploying and destabilizing a set of structuring binaries. With formerly transparent front windows at each venue transformed into opaque cinematic screens, each site welcomed its visitors with two immediately distinct registers of images. On the left was a vivid scene of multiple Earths

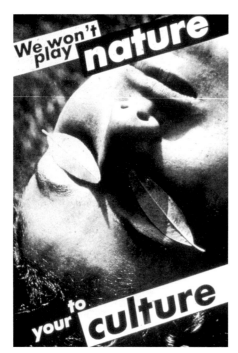

Fig. 4: Barbara Kruger (American, b. 1945), *Untitled (We Won't Play Nature to Your Culture)*, 1983. Gelatin silver print, 73 x 49 in. (185.4 x 124.5 cm). Courtesy Sprüth Magers, Berlin

and revolving moons, all set against a starry, dark sky, as if pulled from the live feed of an orbiting NASA satellite. On the right whirled a receding watery, vaginal vortex of decorative polka dots, as if Yayoi Kusama had consulted Pipilotti Rist and Mona Hatoum to produce a psychedelic video project with an endoscopic camera. The "screens" were separated by a third section, emphatically vertical, decorated by the repeating pattern of the fleur-de-lis, the stylized lily of the French monarchy and heraldic emblems. At turns epic and intimate, masculine and feminine, the iconographic program of *Gender Specific* rehearsed yet somehow also reimagined a set of assumptions about gender, an aesthetic ambition only amplified by additional elements that filled the sites' interiors, with globes dangling in what was designated as the "male" side and water-patterned wallpaper installed on the "female"side.[2]

The 1970s was a fertile time for both artists and academics. At precisely the same moment that Chicago and Schapiro were working with their feminist sisters in Los Angeles to create *Womanhouse*, scholars across academic disciplines were digesting the political lessons of the 1960s and beginning to question their own intellectual formations and inheritance. In 1971, art historian Linda Nochlin penned the feminist salvo "Why Have There Been No Great Women Artists?,"

and in the following year, anthropologist Sherry B. Ortner produced another essay in the form of a question, "Is Female to Male as Nature Is to Culture?"[3] What were foundational feminist questions in the 1970s returned as forceful feminist critiques in the 1980s. As but one example, a piece like Barbara Kruger's 1983 *Untitled (We Won't Play Nature to Your Culture)* (fig. 4) refused the very terms that Nochlin and Ortner had so bravely articulated and interrogated. By the time that Steinkamp created *Gender Specific* in 1989, the terms were shifting yet again. Indeed, *Gender Specific* debuted just a year before feminist philosopher Judith Butler would publish her field-defining deconstruction of gender and identity, *Gender Trouble.*[4]

In retrospect, Steinkamp's installation seems acutely attuned to all that would soon emerge from that transformational political and theoretical moment. As a female artist working with the most sophisticated computer graphics and technology, Steinkamp's visual and architectural scrambling of gendered conventions and cultural assumptions anticipated something of Butler's thesis, even as it echoed and amplified some of the most important claims of that prior generation of feminist practitioners and theorists. With its planets and polka dots, dangling globes and glossy wallpaper, the multimedia installation *Gender Specific* retrofitted the architectures of industry and domesticity to create a kaleidoscopic confrontation with gender norms and expectations.

Binary logic defines *Gender Specific*, from its splitting of the exhibition sites to the deliberate divisions in its iconographic program. And then there is the matter of code. Steinkamp's work may simultaneously demonstrate and defy the divisive logic of binary thinking. But it remains rooted in a computational process that relies on two numbers—0 and 1. Nothing and something, black and white, absence and presence, femininity and masculinity, the list goes on, enumerating a set of oppositions that, like numbers, may feel intensely real, even as they are, ultimately, only concepts, ideas, and abstractions.

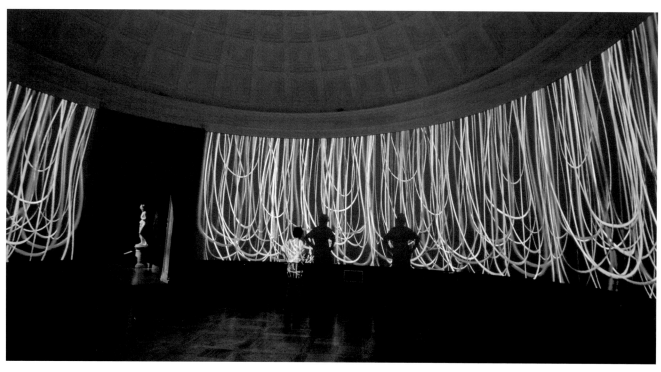

Fig. 5: Jennifer Steinkamp; Jimmy Johnson, soundtrack, *Loop*, 2000. Video installation, Corcoran Gallery of Art, Washington, DC, 13 1/2 x 43 ft. diam. (4.11 x 13.10 m diam.). Collection of George Washington University

ABSTRACTION

For much of the decade after *Gender Specific*, Steinkamp put aside its space-age imagery and pursued instead its psychedelic, Op Art aesthetics, forsaking figuration for abstraction. That period of primarily abstract experimentation came to something of a culmination in the year 2000, when the Corcoran Gallery of Art in Washington, DC, invited Steinkamp to participate in its 46th biennial exhibition, *Media/Metaphor*. With her contribution, produced in collaboration with composer Jimmy Johnson, Steinkamp sharpened her focus on the inheritance of abstraction, harnessing years of experience with the software of computer-generated animation to depict and disentangle the collapse of line and color that was so central to the practice and theorization of modernist painting. At once stubbornly realistic and utterly abstract, vividly present and entirely virtual, *Loop* (fig. 5) transformed the rotunda into an enveloping scrim of gently swaying, colorful ropes—a cowboy's lasso and a painter's skein coupling to conjure the ghostly presence not just of Jackson Pollock in person but also of his most energetic and expansive abstractions. In addition, its title pulled the piece in two further directions, gesturing back toward the material and decorative traditions of weaving and the loom even as it insistently reminded viewers of its illusory status and means of projection in and through the repetitions of the video loop.

By 2010, when Steinkamp created the sinuous set of virtual abstractions bearing the title *Premature* (pp. 39–41), she had long since returned to figuration, to the flowers and trees that would become her signature subjects. But then too, even her most obdurate untitled abstractions never fully escaped the pull of signification. As in the case of *Loop*, *Premature* is by no means simply a technically ambitious simulation of modernist painting for the age of new media, even if its virtual surfaces rival Pollock's

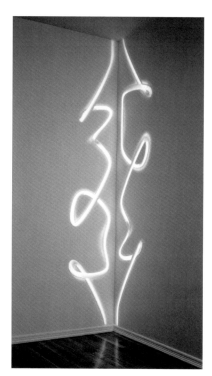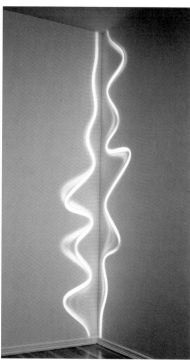

Figs. 6a–b: Jennifer Steinkamp, *I want to be a cowboy,* 2002. Video installation, 10 x 2 x 2 ft. (3.05 x .61 x .61 m)

most monumental canvases or Mark Tobey's most lyrical and calligraphic paintings. And like the 2002 corner piece *I want to be a cowboy* (figs. 6a–b), a languid, liquid pair of Dan Flavin-like fluorescent bulbs crackling with the raw masculine energy of all that came east from Cody, Wyoming, *Premature* creates a quieter, more contemplative, even commemorative atmosphere. Where *Loop* and *I want to be a cowboy* summon inanimate materials and suffuse them with life, *Premature* gives birth to something more bodily, its interwoven skeins of colored cord and tangled tubes thickened to suggest arteries and intestines, if not also umbilical cords. The title burdening that writhing entity with the specter of mortality, the cords convey not only their function as a conduit of fetal

sustenance, but also the terrifying possibility of their tightening into a lethal, serpentine noose.

Natality and mortality are not the only metaphors that circulate through *Premature*. Corporeal as the cords may be, they are also still connected to the legacy of the abstract pictorial practices they so readily summon, practices whose death knell has been sounded for decades.[5] In turn, the title puts pressure on the ghost of abstraction, even as the piece summons that nonfigurative idiom back from the dead. For, despite the anticipatory ambitions of the self-proclaimed avant-garde, "too soon" is all too rarely the temporality of a work of art. With every passing generation, artists are all the more aware of coming too late, toiling in the aftermath of their predecessors, wrestling with an inheritance that is as imperiling as it is inspiring.[6]

Like Steinkamp, the post-minimalist sculptor Eva Hesse recognized the metaphoric possibilities of Abstract Expressionism's painterly line, all the energy and ego of its signature surfaces experienced and then fashioned as a suffocating legacy. Where some of Hesse's works,

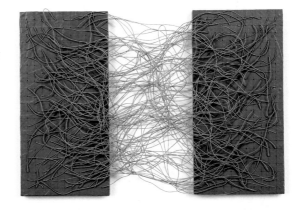

Fig. 7: Eva Hesse (American, b. Germany, 1936–1970), *Metronomic Irregularity I*, 1966. Graphite, acrylic, papier-caché, Masonite, cotton-covered wire, 12 x 18 x 2 in. (30.4 x 45.7 x 5.1 cm). Museum Wiesbaden, Germany. © The Estate of Eva Hesse. Courtesy Hauser & Wirth

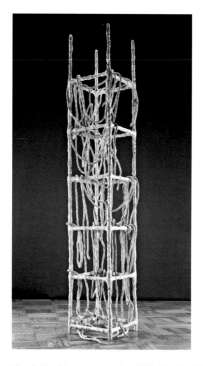

like *Metronomic Irregularity I* (1966; fig. 7), play with that temporal paradox in ways that had no specific historical anchor, her *Laocoön* (1966; fig. 8) reaches back to classical antiquity to unleash the full metaphoric force of her sculptural program. In the place of the doomed Greek hero and his sons, bound and drowned by encircling snakes, Hesse constructed an abstracted skeleton in and as a minimalist cage of calcified papier-mâché, its attenuated armature at once supporting and suffering under the weight of serpentine coils of tubing and the burden of all that inherited tradition.

Where Hesse's work dramatizes that disabling logic, her suggestive sculptural forms serving at times as a painfully intimate archive of wounding and trauma,[7] Steinkamp's *Premature* has a lightness that is not only a function of its illusionistic premise and promise. Realized through the churning of computer code, the product of pure computational operations, it flirts with the fantasy in which corporeality is transcended, delivering the digital dream of disembodied being. And yet, for all that intimation of liberation from the bonds and burdens of the body, it remains tethered to tradition, anchored by archetypes both ancient and modern.

Fig. 8: Eva Hesse, *Laocoön*, 1966. Plastic tubing, rope, wire, papier-mâché, cloth, paint, 130 x 23 1/4 x 23 1/4 in. (330.2 x 59 x 59 cm). Allen Memorial Art Museum, Oberlin College, Oberlin, Ohio. Fund for Contemporary Art and gift from the artist and Fischbach Gallery, 1970. AMAM 70.32. © The Estate of Eva Hesse. Courtesy Hauser & Wirth/Bridgeman Images

FLORA

"Rapunzel, Rapunzel, let down your hair." Some among us may recall these words from the fairy tales compiled during the first decades of the nineteenth century by the Brothers Grimm. Harrowing and haunting tales of abandonment and violent punishment, their origins are oral but their final form is literary, intended, at least initially, as much for adults as for children.[8] The tale of Rapunzel is a particularly striking example of their collective efforts. The long-awaited daughter of a couple seemingly doomed to infertility, she is bartered before her birth for a supply of the plant (known variously as *Campanula rapunculus*, Rapunzel, rampion, ramps) that her pregnant mother craves and that her father has been caught stealing on her behalf from his neighbor's garden. Raised not by the parents who forsake her but instead by the evil neighbor, Mother Gothel (be she witch or archetypal evil stepmother), Rapunzel grows into a beautiful young woman, her golden hair but one marker of her desirability. To protect her adopted child, the older woman locks her in a tower, its only means of egress a high and narrow window.

From this prison aerie, Rapunzel sings and periodically lets down her hair. Lured by the beauty of her voice, a passing young prince seeks its source. And her golden tresses prove a serviceable ladder. Over time, at least in the franker first edition of the tale, her dress grows tight. And her captor, realizing what has come to pass, cuts off her hair and banishes her to the wilderness. Wholly unaware of what has transpired in his absence, the next time that the young prince visits, he is met with a terrible shock. He climbs the dangling hair imagining he will, once again, be united with his beloved and finds instead the vengeful woman. Although he escapes her clutches by jumping from the tower, in his fall, he is blinded by thorns. After wandering the countryside searching for his beloved (and, unbeknownst to him, his children—twins), he is lured once again by her voice.

In that moment of reunion, his sight is restored by her tears, her hair by his touch, and the prince and his princess bride return to the castle and live, as the saying goes, happily ever after.

Steinkamp certainly remembers the tale. In *Rapunzel* (2005–14; pp. 43–47), a piece that is at turns, on her account, autobiographical and allegorical, she translates familial trauma into Technicolor display, using an algorithm that was specifically created to simulate the motion of hair.[9] But hair we do not see. Instead, we see delicate strands of flowers, each vine heavy with colorful blooms. This floral iconography first blossomed when Steinkamp coupled the code of *I want to be a cowboy* with that of flowers to produce *Jimmy Carter* (2002; fig. 9). Whatever its experimental impetus, its emergence was quite timely and, in its titling, came to honor the former president's commitment to world peace and his receiving of the Nobel Peace Prize. All of which is to say, by 2005, when Steinkamp created the first iteration of *Rapunzel*, she could harness that technical knowledge and reimagine the metaphorical possibilities of that floral imagery to create an evocative ode to all that was embodied in that fairy-tale figure of femininity. Stem and vine, leaf and flower, all come together to form the virtual tapestry that is equal parts Rapunzel's cascading hair and the fruits of the forbidden garden that furnishes her name.

The flower pieces also return us to an issue that has structured Steinkamp's work since the moment she mounted patterned wallpaper in the interior of her inaugural installation, *Gender Specific*, namely, the vexed relation of painterly abstraction to decorative practices often coded, and in turn, denigrated, as feminine.[10] From Wassily Kandinsky's *Concerning the Spiritual in Art* (1910) to T. J. Clark's "Jackson Pollock's Abstraction" (1986), there is an abiding anxiety, expressed by Kandinsky, historicized by Clark, that abstraction, for all its art historical lineage and avant-garde ambitions, cannot escape collapsing back into the "merely" decorative.[11]

running through a season's worth of color upon branches that wriggle like snakes.

Eye Catching is not only the first of her installations to introduce a visually arresting set of virtual trees, all twisting and turning in ways that echo the Enchanted Forest of The Wizard of Oz, particularly in its cinematic incarnation, even as they also assert their place in a lineage of landscape painting that spans from Jacob van Ruisdael to Caspar David Friedrich to Thomas Cole. The trees in Eye Catching also summon the spirit and form of Medusa, their writhing branches mirroring and animating the mythical snake-haired figure whose carved head adorned the bases of two columns in its striking installation site. Set amid the architectural remains and ruins of an underground cistern (Yerebatan Sarnıcı, the Sunken Palace), Eye Catching transforms the site's subterranean walls into a backdrop for a mesmerizing virtual

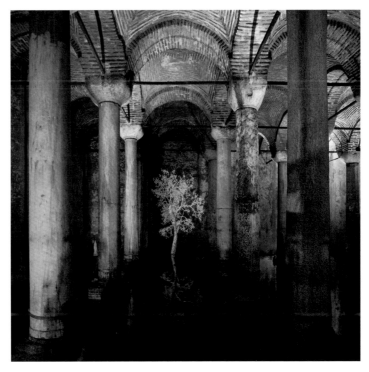

Fig. 10: Jennifer Steinkamp, Eye Catching, 2003. Video installation, Yerebatan Cistern, Istanbul, two parts, 20 x 14 ft. (6.09 x 4.26 m) each

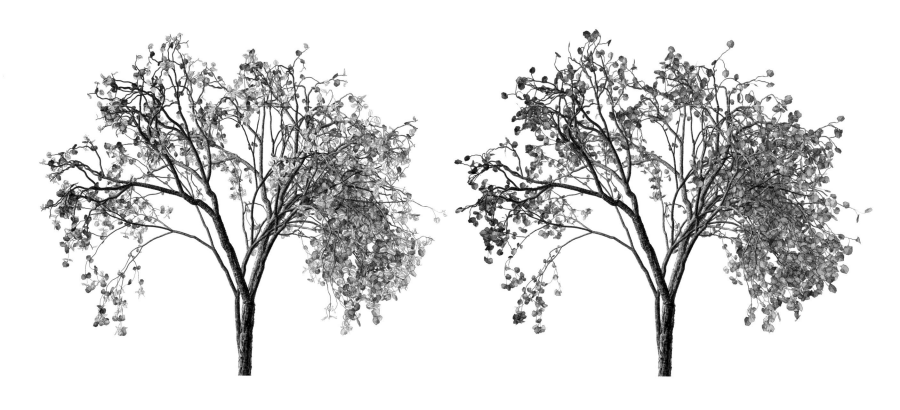

Figs. 11a–d: Jennifer Steinkamp, *Dervish*, 2004–5. Video installation, dimensions variable

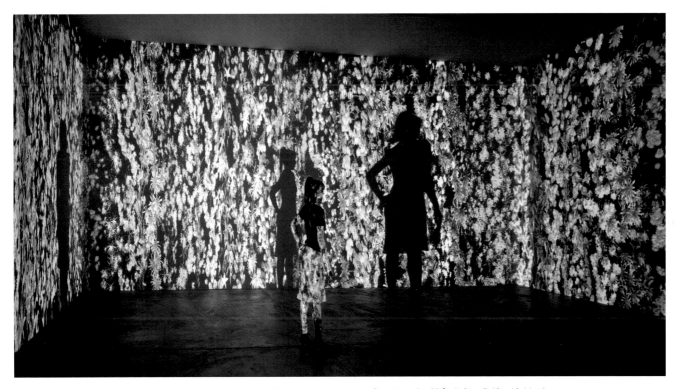

Fig. 9: Jennifer Steinkamp, *Jimmy Carter*, 2002. Video installation, ACME, Los Angeles, 14 x 18 x 35 ft. (4.26 x 5.48 x 10.66 m)

For female artists and feminist scholars alike, particularly since the 1970s, the decorative is neither to be feared nor disparaged. What was once reviled could return as a source of revelation. Take, for example, the inheritance of a text like Charlotte Perkins Gilman's "The Yellow Wallpaper." Certainly, as Steinkamp made clear in a 2008 interview, there is an uncanny connection between "The Yellow Wallpaper" and her work. Pressed to comment on that connection, Steinkamp responded:

> I know. I used to stare at the yellow floral wallpaper in my bedroom when I was a child. I could imagine the flowers changing, or I could make out various faces in each one. The first piece where I used flowers was *Jimmy Carter* (2002). . . . At that time, I was not thinking of the projection as wallpaper, although the installation created an immersive space and covered three large walls full of flowers.[12]

"The Yellow Wallpaper" has been a key text for feminist literary scholars since it was rescued from literary oblivion and reissued by the Feminist Press in 1973; given its visual metaphors, it ought to be for art historians as well.[13] Published in 1892, it tells the tale of a rest cure gone terribly awry.[14] Its protagonist is a writer, a loosely veiled double of the author, confined to the derelict nursery of a colonial mansion. Forbidden by her husband to write, one among many prohibitions in her infantilizing return to the nursery, the woman becomes obsessed with the visual details of her radically delimited surroundings, most notably its fading, peeling wallpaper. As she studies its surface, the wallpaper takes on legible form. Its "florid" pattern captures her imagination; "behind the (pointless) pattern" she finds "a strange, formless sort of figure that seems to skulk about behind

that silly and conspicuous front design," "like a woman stooping down and creeping about." A site of identification and projection, the woman in the yellow wallpaper engages in a futile struggle for liberation from the visual pattern that is her prison-house: "and she is all the time trying to climb through. But nobody could climb through that pattern—it strangles so."[15]

Not all floral schemata give way to serpentine tresses, as they do in *Rapunzel*. And, in turn, not all floral schemata induce nightmares of entrapment. Sometimes, as in Steinkamp's 2014 *Diaspore* (pp. 57–63), floral schemata can be reconfigured into clusters suggestive of tumbleweeds. Loose tangles of vines, leaves, and flowers, the tumbleweeds skitter across the dark backdrop of an implied landscape, their lateral movement signaling nothing so much as freedom. Spreading spore and seed as they go, these seemingly self-propelled parcels are also self-perpetuating, a means of securing their lineages. In its deliberate spelling, *Diaspore* asserts the botanical. But it also opens into the historical, taking us from the displacement of the Jews from Israel to any number of forced migrations from former homelands. And as it offers up a virtual image of unfettered movement, it morphs into contemporary political allegory, a glimpse of freedom when a global flow of refugees faces borders and boundaries all too often blocking their movements and thwarting their dreams.

Might *Diaspore* also signal something more profound about this arena of digital design and dissemination? Nothing but code and with no place to call home, the immaterial numerical nomads of new media culture occupy a virtual space that is a non-place. There is a word for the non-place—the no place—namely, utopia. A philosophy of the future with roots in the imagined paradises of antiquity, its secularized messianism is driven as much by cultural fantasy as by social urgency, as much by Thomas More's 1517 *Utopia* and literary and cinematic science fiction as by the political theories of Karl Marx, Friedrich

Engels, Ernst Bloch, and Herbert Marcuse.[16] Certainly, some number of these strands come together across Steinkamp's career. Even if not inflected, in any manifest way, by that body of political theory, her work does find inspiration, visually and thematically, in the genre of science fiction.[17] But perhaps even more than the non-place that we know as utopia, Steinkamp's artificial nature is oriented not so much toward a future that is always asymptotically just beyond our grasp, but instead, toward a past that is as mythical as it is historical. In other words, perhaps that non-place summoned in her hyperrealist, artificial natures is not a more perfect future but a paradise lost. And how better to approach that imagined idyll than to turn to its most iconic emblem, the tree, particularly when that tree is coupled with the seductive serpent lurking in its branches?

TREES AND SERPENTS

The year 2003 stands as something of a turning point in Steinkamp's career, at once the moment when a California-based artist entered fully into an international arena and when a defining new iconography emerged. Invited to participate in the 8th Istanbul Biennial, Steinkamp contributed a piece called *Eye Catching* (fig. 10), a set of virtual trees whose variously bare or leafy branches are animated by the same sorts of writhing, serpentine undulations that have characterized many of her preceding abstractions and contemporaneous scrims of flowers. Over the fifteen years since she created that first arboreal installation, trees have come to be a signature subject in her work, from the whirling branches of *Dervish* (2004–5; figs. 11a–d) to the foliated follies of the series *Fly to Mars* (2004–10; pp. 49–55). With an aspirational title that belies its earthbound subject (unless we see its simulation of the natural world as a correlate of a future SpaceX mission), *Fly to Mars* transforms mature trees into massive, limber saplings,

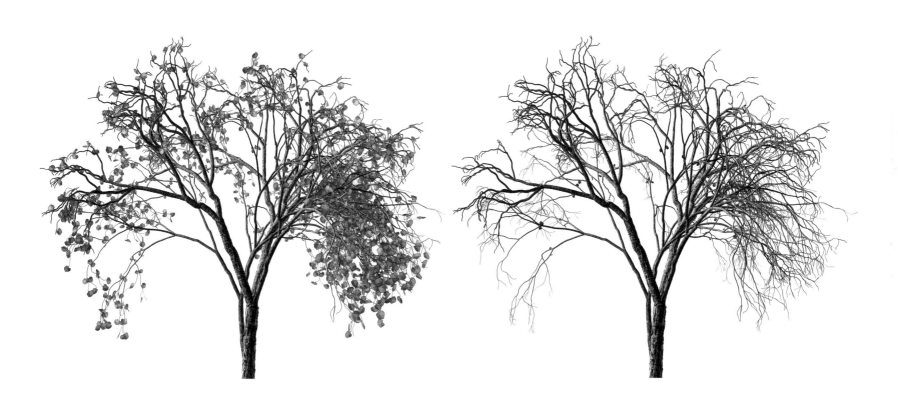

performance. If their serpentine undulations here summon forth that Greek Gorgon, in all her apotropaic power, that pagan past cannot be entirely disentangled from the subsequent transposition of something of that snake who haunts the Abrahamic religions, the sibilant satanic serpent who, particularly in the Judeo-Christian tradition, ushers mankind into carnality (Hebrew scripture) and sin (New Testament).[18]

And it ushers viewers of Steinkamp's work into an ever-shifting surround, where serpentine cords, undulating floral tresses, and wriggling trees come together to form a virtual visual spectacle of that ancient enchanted garden. Inflected by the sacred, Steinkamp's installation engineers an experience of the natural world that is not only luminous, but perhaps, ultimately, numinous. For in that moment of immersive encounter, we see the garden from a position of omniscience, a prelapsarian perspective that is at once Adam's, and Eve's, and, depending on our disposition, that of the divine.

CODA

And then there is the dense forest of birch trees, spread laterally across an entire gallery wall. Inspired and designed specifically in response to the landscape that surrounds the Clark, *Blind Eye* (2018; pp. 65–75) inaugurates a departure even as it retains much of what came before. For it is neither the foliage nor the branches that make the birch tree so distinctive. It is its bark, pocked by dark scars that, as Steinkamp's title suggests, look like nothing so much as unseeing eyes. The bark of the birch tree is loose and papery, ranging in tone from ashen gray to pure, snowy white. The birch tree sloughs off that bark as a snake might shed its skin. And if, as I have suggested, there is something almost sacred at the heart of

Steinkamp's repertoire, the forest of birches secures that suspicion. For *Blind Eye* not only gives us the seductive image of a snakelike tree. *Blind Eye* also puts us in the virtual presence of nature as the site and source of a woody parchment that conjures nothing so much as a biblical Torah scroll.[19] Conflating nature and culture, secular and sacred, *Blind Eye* stands as emblematic of all that animates Steinkamp's virtual worlds.

[1] Michael Fried, "Art and Objecthood" (1967), as reprinted in his *Art and Objecthood* (Chicago: University of Chicago Press, 1998), 148–72.

[2] For further discussion and description of *Gender Specific*, see JoAnne Northrup, "Juniper," in *Jennifer Steinkamp*, exh. cat. (San Jose: San Jose Museum of Art; Munich: Prestel, 2006), 25–28; and Carole Ann Klonarides, "Interview with Jennifer Steinkamp," in *California Video: Artists and Histories*, ed. Glenn Phillips (Los Angeles: Getty Publications, 2008), 210–13. Although I have seen no photographs of the interior, and did not see the installation, in addition to the globes and watery wallpaper, the bathroom was apparently furnished with "gender neutral" reading material.

[3] Linda Nochlin, "Why Have There Been No Great Women Artists?," *ARTNews* (January 1971): 22; and Sherry B. Ortner, "Is Female to Male as Nature Is to Culture?," *Feminist Studies* 1, no. 2 (Autumn 1972): 5–31. Where Nochlin looked at social history and institutional impediments to explain both historical and contemporary inequities in the world of art, Ortner turned to philosophy, principally Simone de Beauvoir's work of feminist philosophy, *The Second Sex* (1949), first to establish, then to challenge, the age-old gendered equation of women with nature, men with culture.

4 Judith Butler, *Gender Trouble: Feminism and the Subversion of Identity* (New York: Routledge, 1990).

5 See, for example, Yve-Alain Bois, "Painting: The Task of Mourning," in his *Endgame: Reference and Simulation in Recent Painting and Sculpture,* exh. cat. (Cambridge: MIT Press, 1986), 29–49.

6 See, for example, Harold Bloom, *Anxiety of Influence: A Theory of Poetry* (New York: Oxford University Press, 1973).

7 See Anna Chave, "Eva Hesse: 'A Girl Being a Sculpture'," in *Eva Hesse: A Retrospective,* ed. Maurice Berger et al., organized by Helen Cooper, exh. cat. (New Haven: Yale University Press, 1992), 99–117.

8 For the full, unexpurgated collection, see Maria Tatar, *The Annotated Brothers Grimm* (New York: Norton, 2012). The literature on fairy tales is wide-ranging in its assessment of their purpose, from the expressly psychoanalytic account of Bruno Bettelheim, *The Uses of Enchantment: The Meaning and Importance of Fairy Tales* (New York: Vintage Books, 1976), to such revisionist accounts as Jack Zipes, *Breaking the Magic Spell: Radical Theories of Folk and Fairy Tales* (Austin: University of Texas Press, 1979). The latter's argument is reprised and expanded in his *The Irresistible Fairy Tale: The Cultural and Social History of a Genre* (Princeton: Princeton University Press, 2012). See also Sandra Gilbert and Susan Gubar, *The Madwoman in the Attic: The Woman Writer and the Nineteenth-Century Literary Imagination* (New Haven: Yale University Press, 2007); and Marina Warner, *From the Beast to the Blonde: On Fairy Tales and Their Tellers* (New York: Noonday Press/Farrar, Straus and Giroux, 1994).

9 For Steinkamp, the tale may be an allegory of many things, but, at its essence, it is a tale about addiction and parental neglect. Jennifer Steinkamp, conversation with the author, January 24, 2018.

10 There are, of course, cultural traditions in which abstraction/ornament takes center stage, whether we look to antiquities from the ancient Near East or the illuminated manuscripts and architectural details of the Islamic world.

11 Wassily Kandinsky, *Concerning the Spiritual in Art* (1912), trans. and with an introduction by M. T. H. Sadler (New York: Dover Publications, 1977); and Timothy J. Clark, "Jackson Pollock's Abstraction," in *Reconstructing Modernism: Art in New York, Paris and Montreal, 1945–64,* ed. Serge Guilbaut (Cambridge: MIT Press, 1990), 172–243.

12 Klonarides, "Interview with Jennifer Steinkamp," 213.

[13] One of the only literary critics to seize on the visual dimensions of the tale is Barbara Johnson, "Is Female to Male as Ground Is to Figure?," in *The Feminist Difference: Literature, Psychoanalysis, Race and Gender* (Cambridge: Harvard University Press, 1998), 17–36. But even as Johnson explicitly draws on the visual arts, deploying terms like "figure" and "ground" (and, it should be noted, echoes the earlier feminist foray of the aforementioned Ortner), her aim is to rethink the issue of sexual difference in psychoanalytic theory, not in visual studies or art history. That the protagonist of "The Yellow Wallpaper" begins to define her subjectivity in relation to the visual world is only, in Johnson's account, a function of her identity as a thwarted writer. As Johnson writes, "It is clear, therefore, that the paper that comes alive on the walls is related to the dead paper on which the narrator is forbidden to write" (p. 24).

[14] Charlotte Perkins Gilman, "The Yellow Wallpaper" (1892), as reprinted in *The Norton Anthology of Literature by Women: The Tradition in English*, ed. Sandra Gilbert (New York: Norton, 1985), 1148–61.

[15] Ibid., 1148-61.

[16] For a discussion of the literatures and philosophies, past and present, of utopia, see Fredric Jameson, *Archaeologies of the Future: The Desire Called Utopia and Other Science Fictions* (London: Verso, 2005).

[17] The flowers that are so central to her repertoire may rise from and echo the fairy tales of the Brothers Grimm, the Gothic imagination of Charlotte Perkins Gilman, and the antiwar emblems of the Summer of Love. But they also find their source in Stanley Kubrick's *2001: A Space Odyssey*. Steinkamp's *Daisy Bell* (2008), for example, may conjure a field dense with writhing flowers. But, in its title, it also expressly summons a history of artificial intelligence, from 1961, when Bell Labs programmed an IBM mainframe to sing "Daisy Bell," to 1968, when, in the harrowing denouement of Kubrick's 1968 cult classic, the increasingly menacing artificial intelligence of the HAL 9000 computer is deactivated and, in its death throes, sings an ever more fractured and halting version of that signature song.

[18] See Elaine Pagels, *Adam, Eve, and the Serpent* (New York: Random House, 1988).

[19] For a discussion of the birch tree and its bark, see Georges Didi-Huberman, *Bark* (2011), trans. Samuel E. Martin (Cambridge: MIT Press, 2017), which opens into a meditation on that meadow of birches *Birkenau*, and the question of witness, the history of the Holocaust, and its representation.

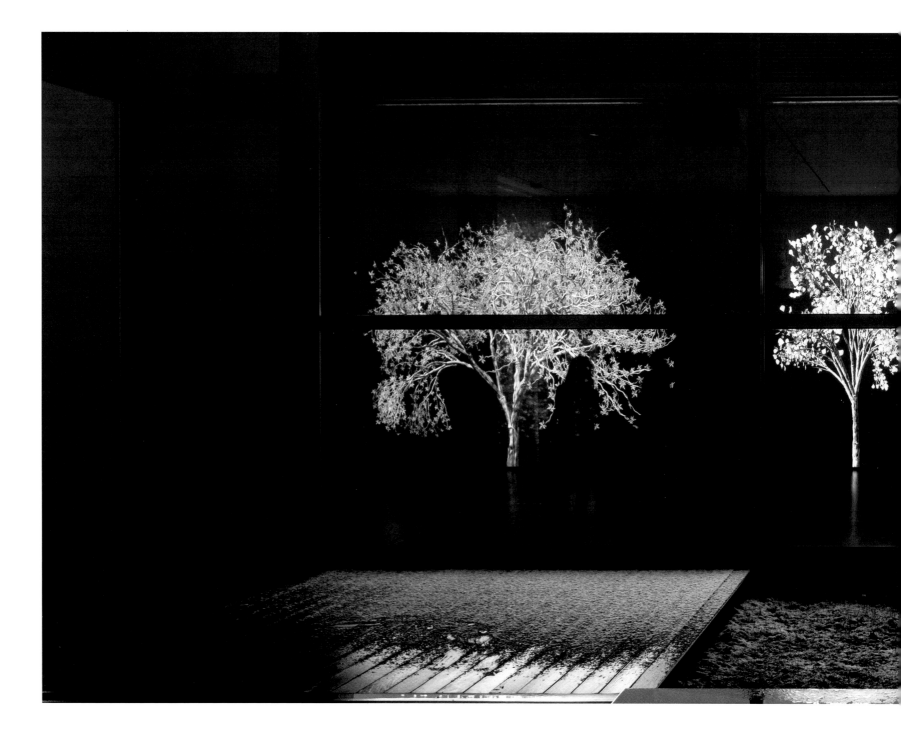

Jennifer Steinkamp: Blind Eye

June 30–October 8, 2018

Lunder Center at Stone Hill

Premature, 6

Premature, 6, 2010
Video installation
11 ft. x 5 ft. 9 in. (3.35 x 1.75 m)

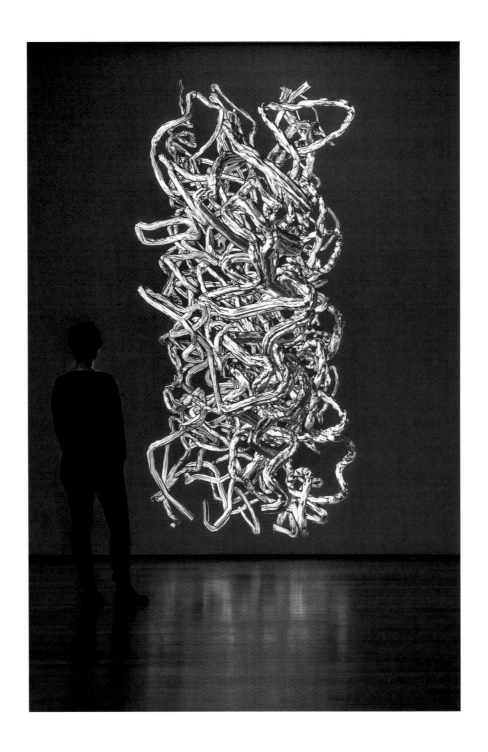

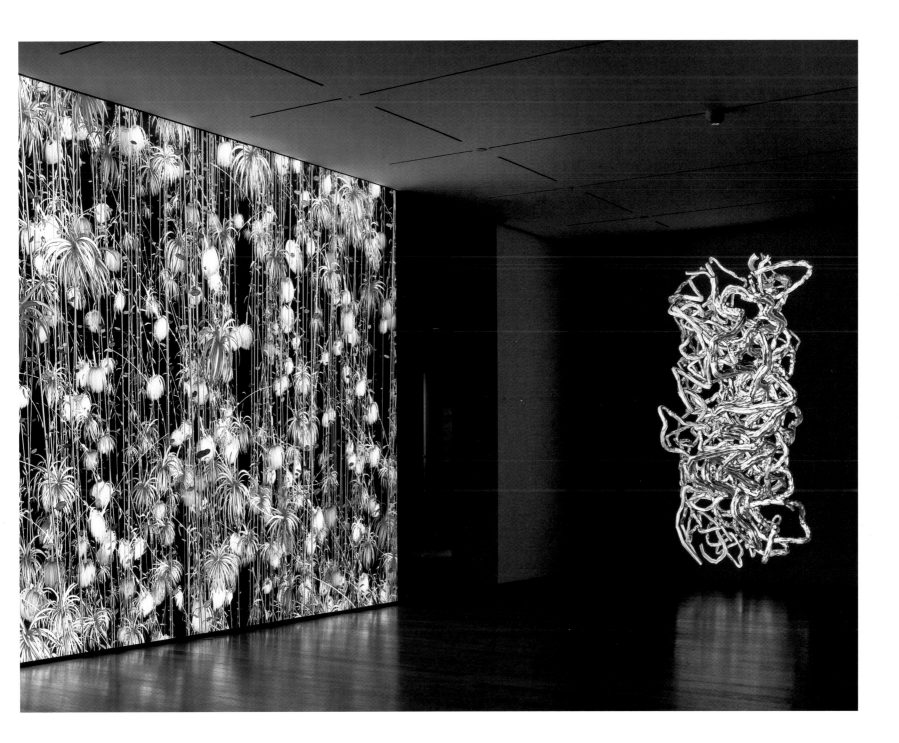

Rapunzel, 5

Rapunzel, 5, 2005
Video installation
12 ft. x 18 ft. (3.66 x 5.49 m)

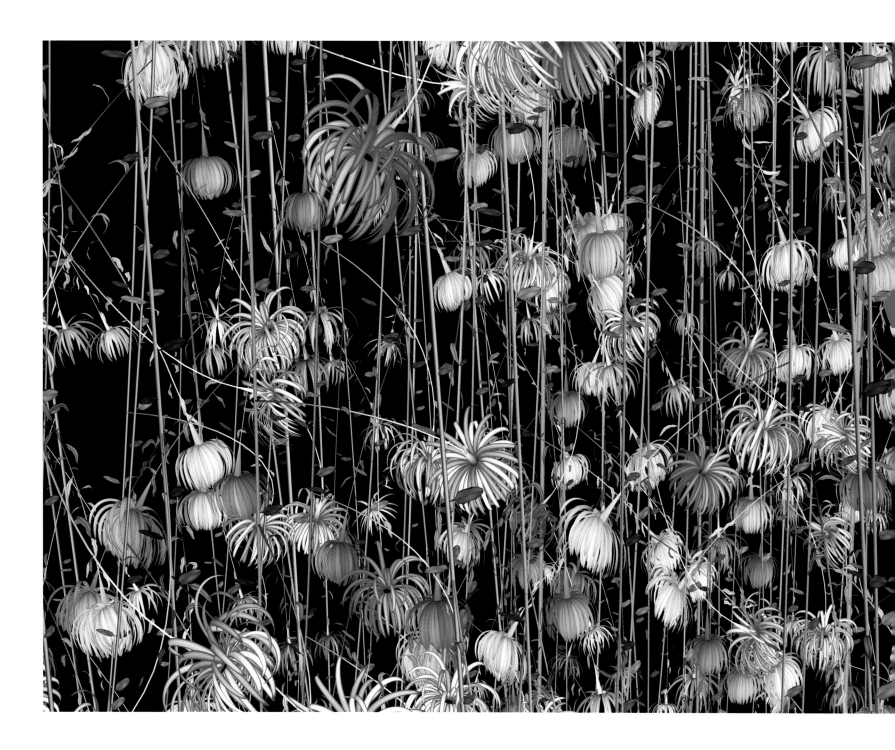

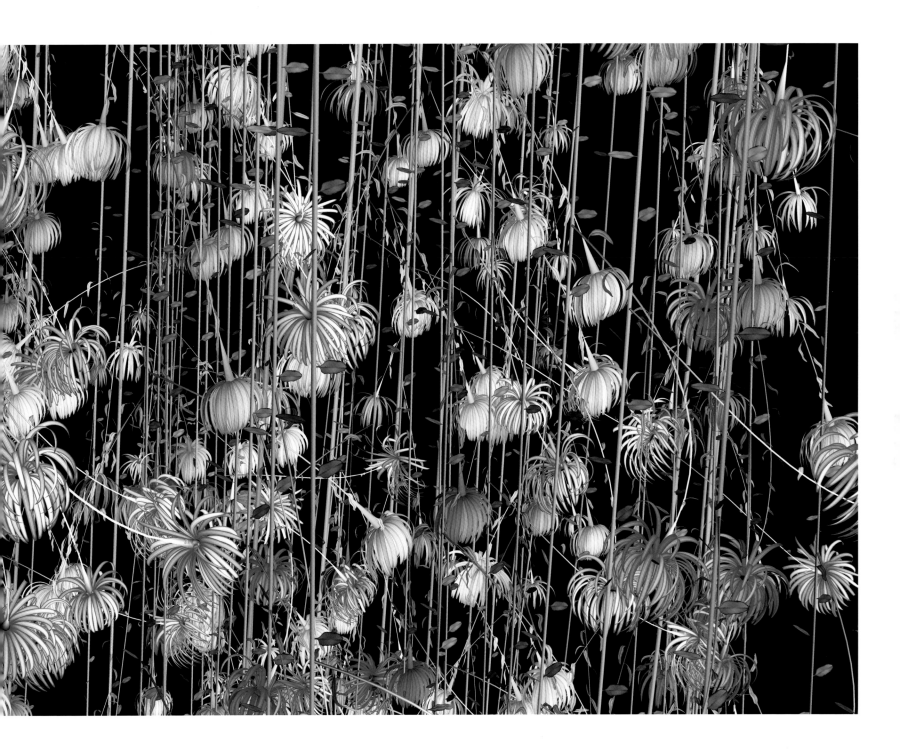

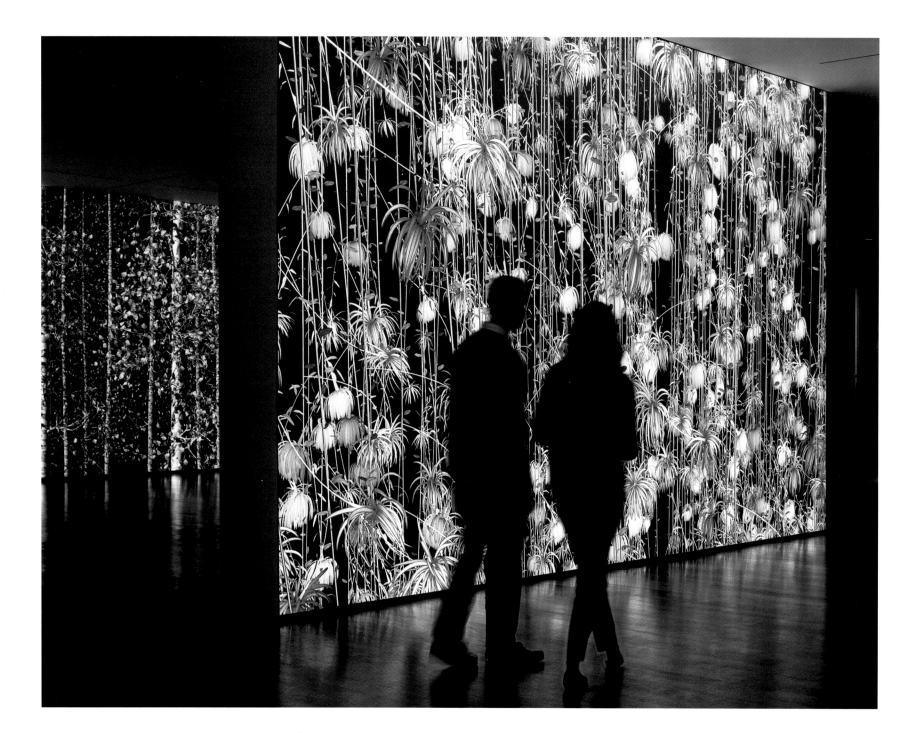

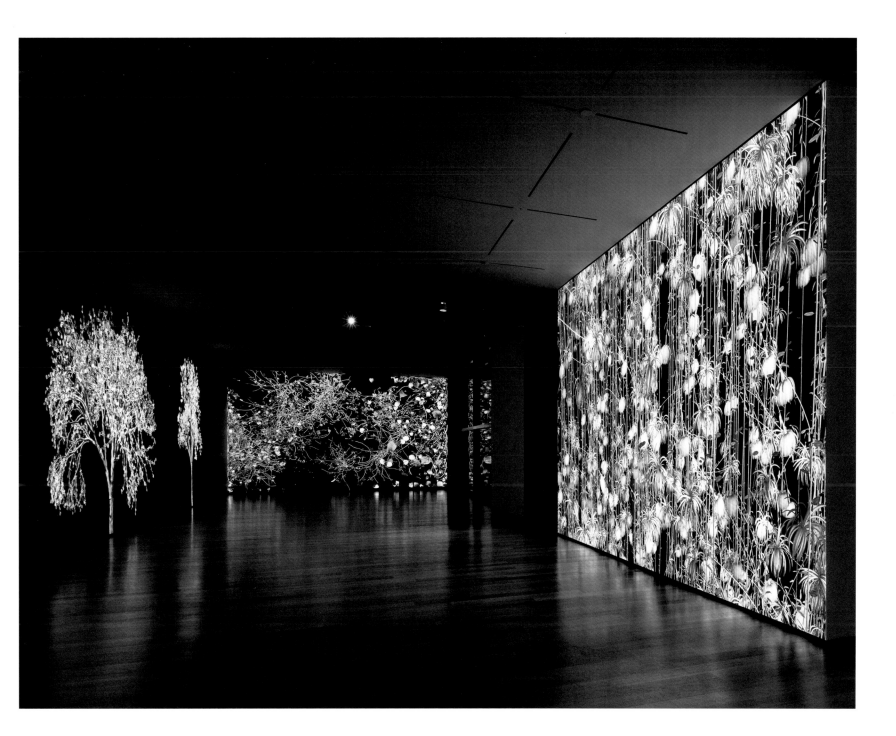

Fly to Mars, 6 and 9

Fly to Mars, 6, 2006
Video installation
12 ft. x14 ft. 10 in. (3.66 x 4.52 m)

Fly to Mars, 9, 2009
Video installation
11 ft. 2 in. x 8 ft. 2 in. (3.40 x 2.99 m)

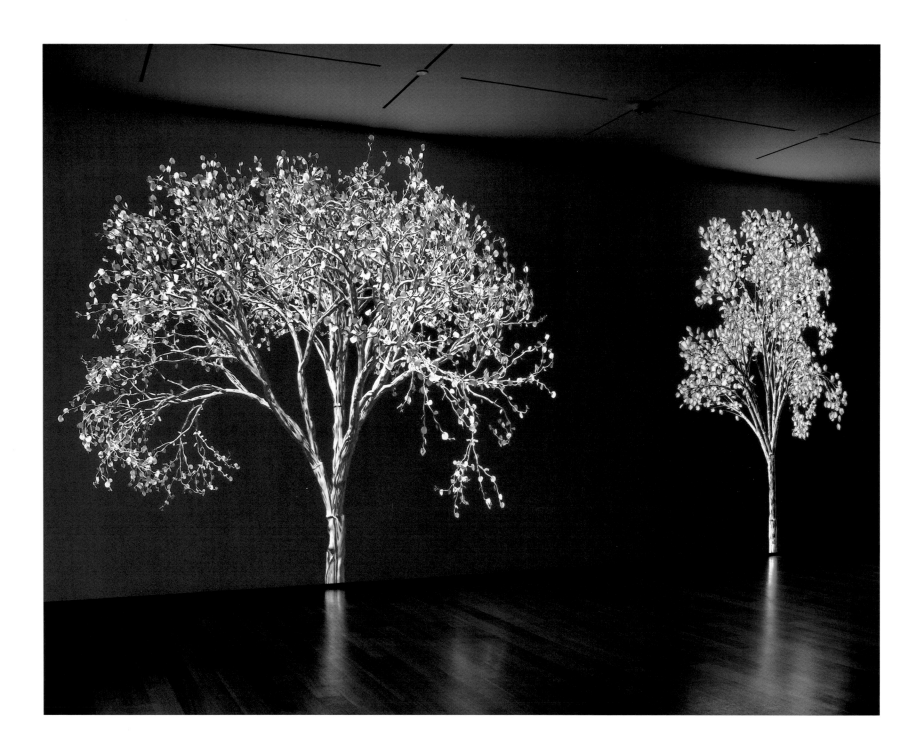

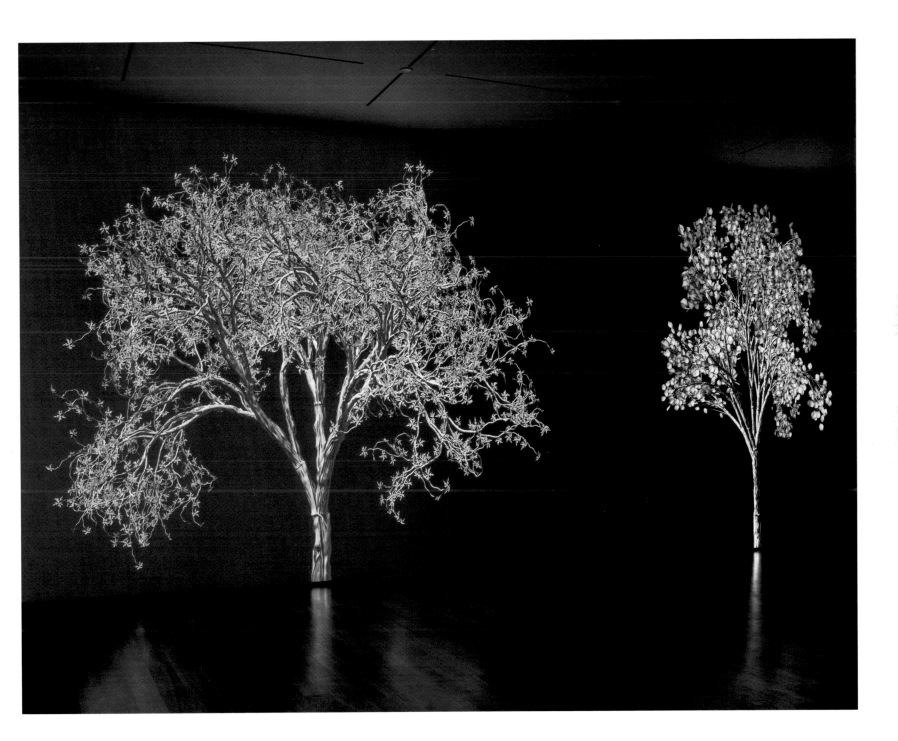

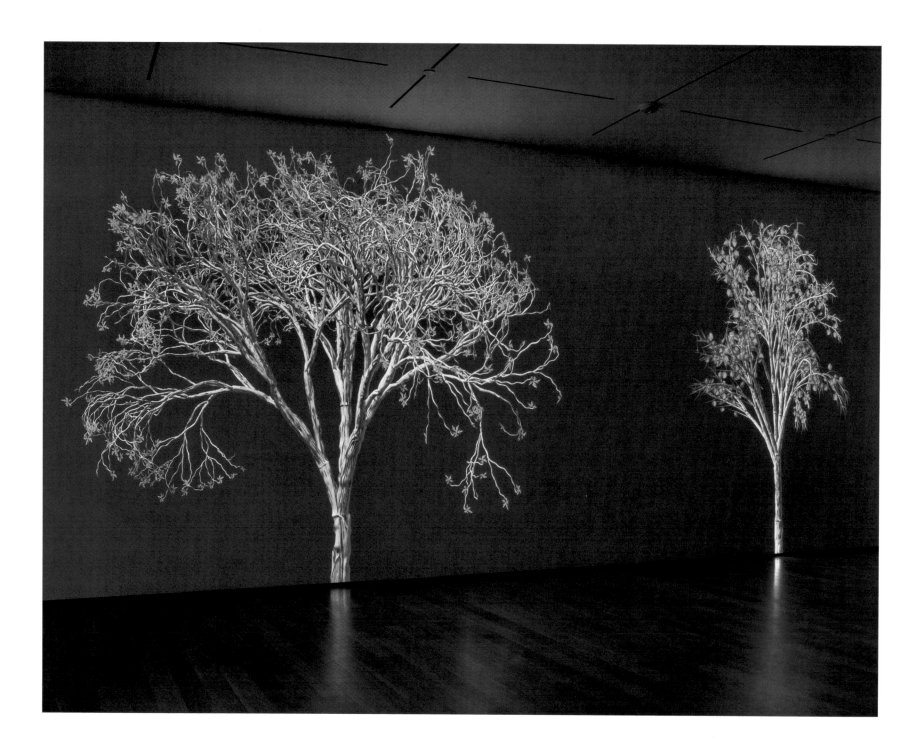

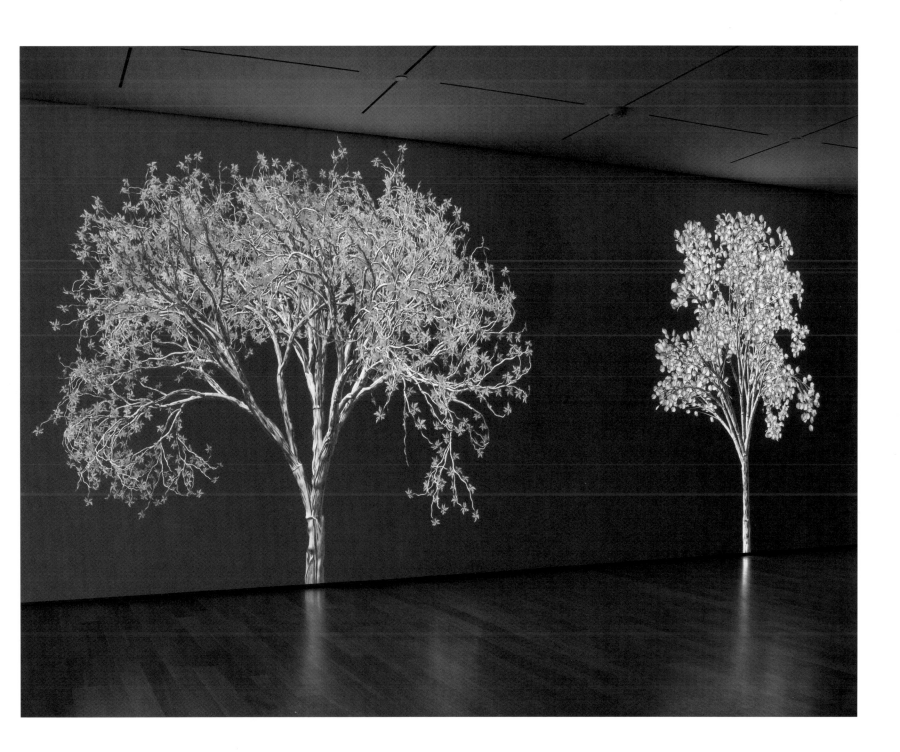

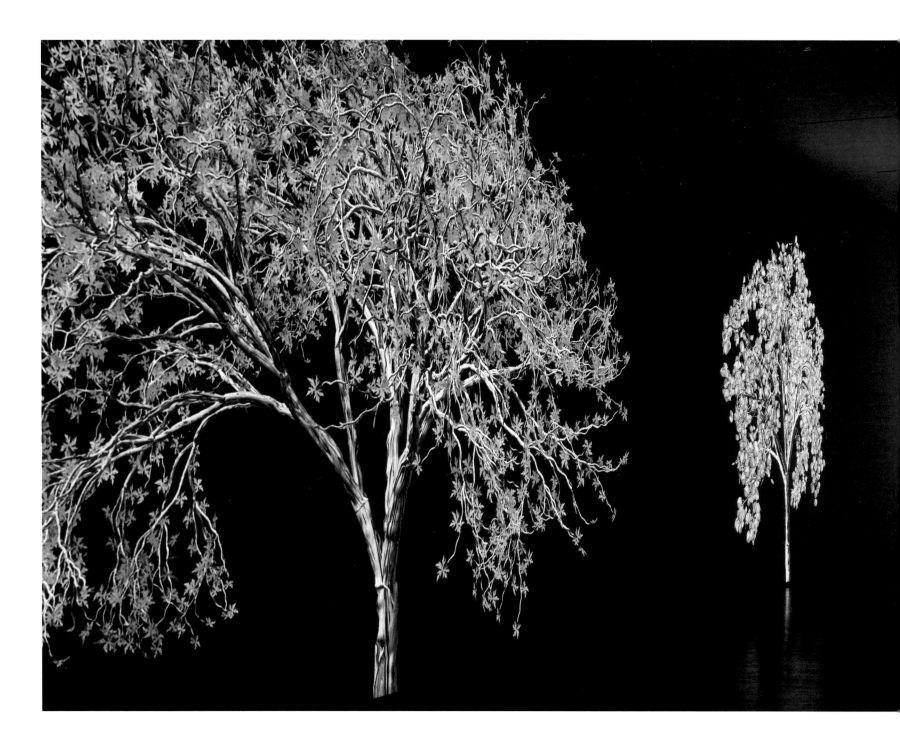

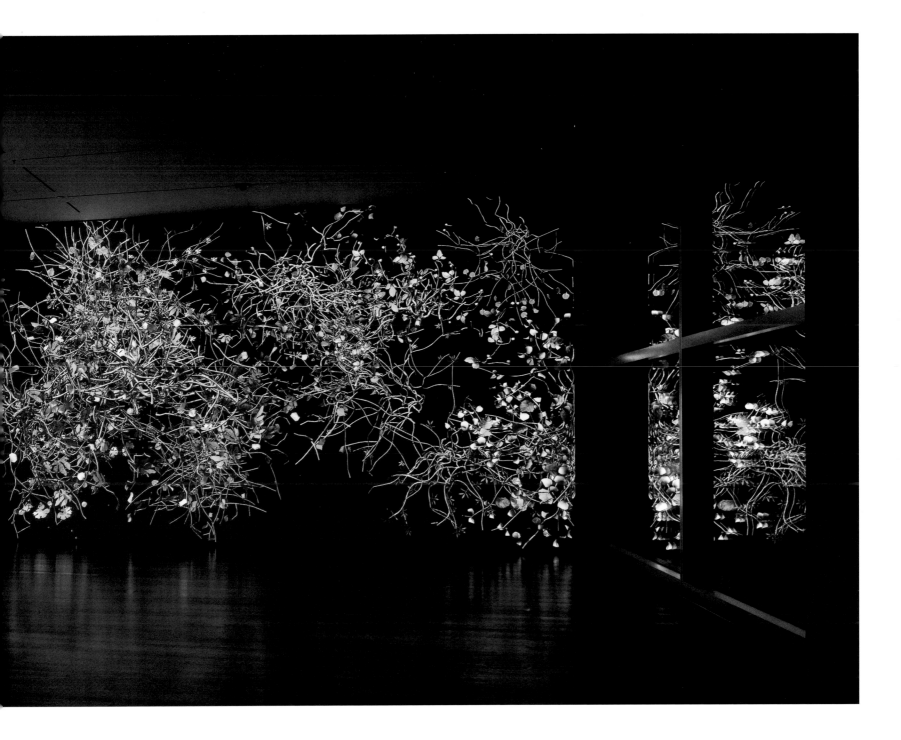

Diaspore, 2

Diaspore, 2, 2014
Video installation
12 ft. x 21 ft. 5 in. (3.66 x 6.27 m)

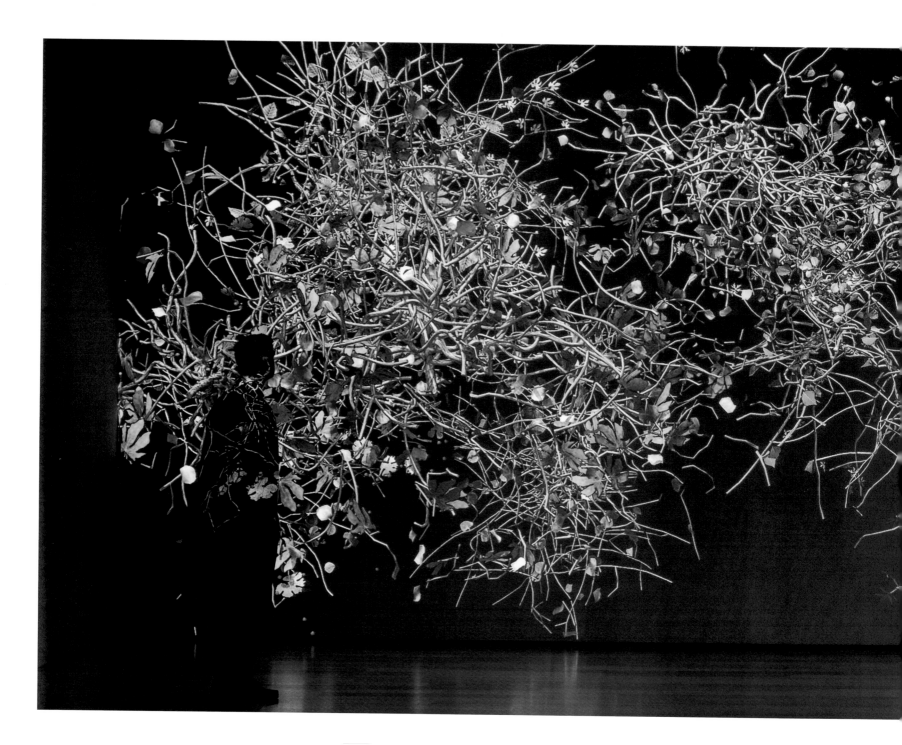

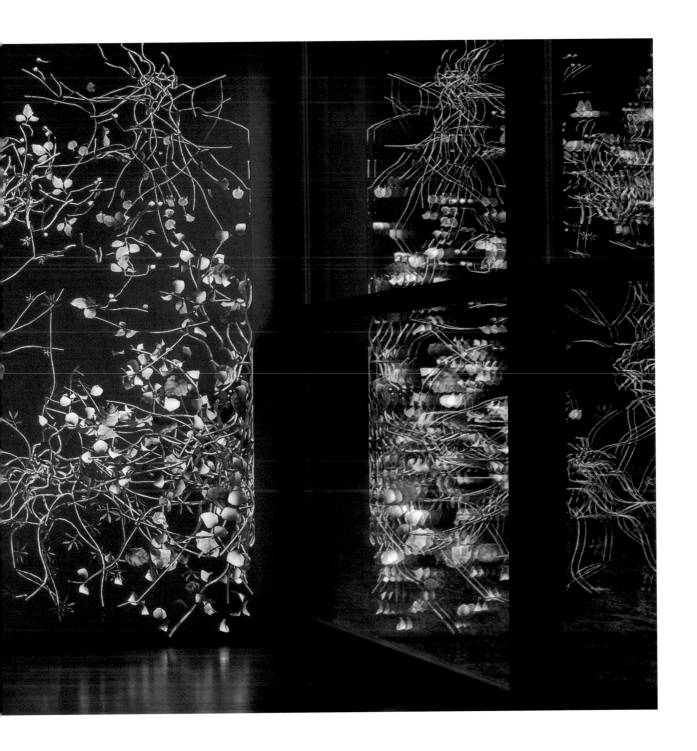

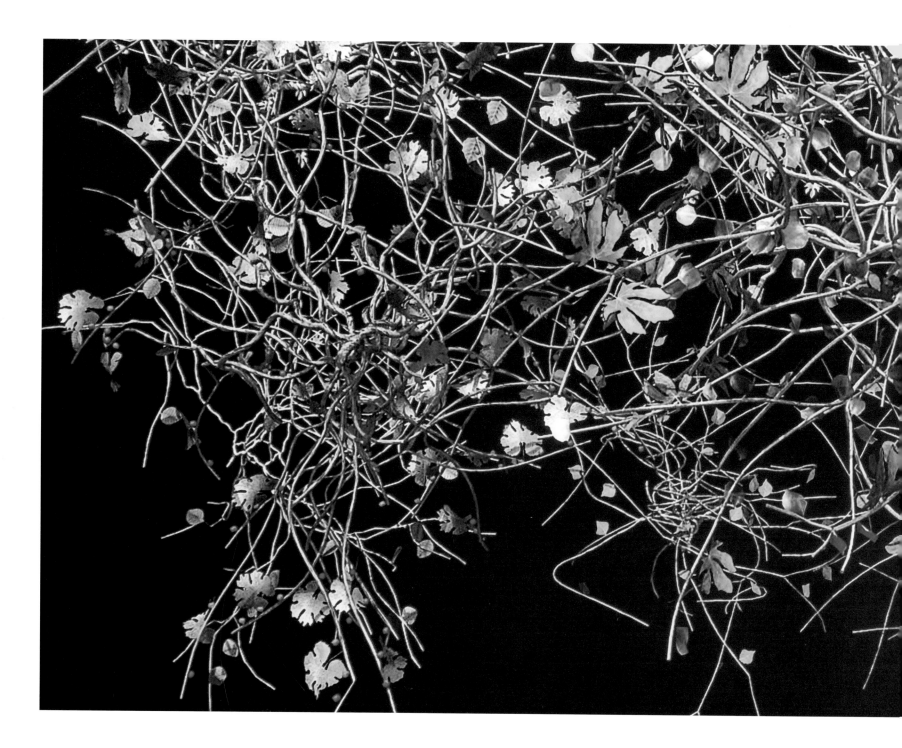

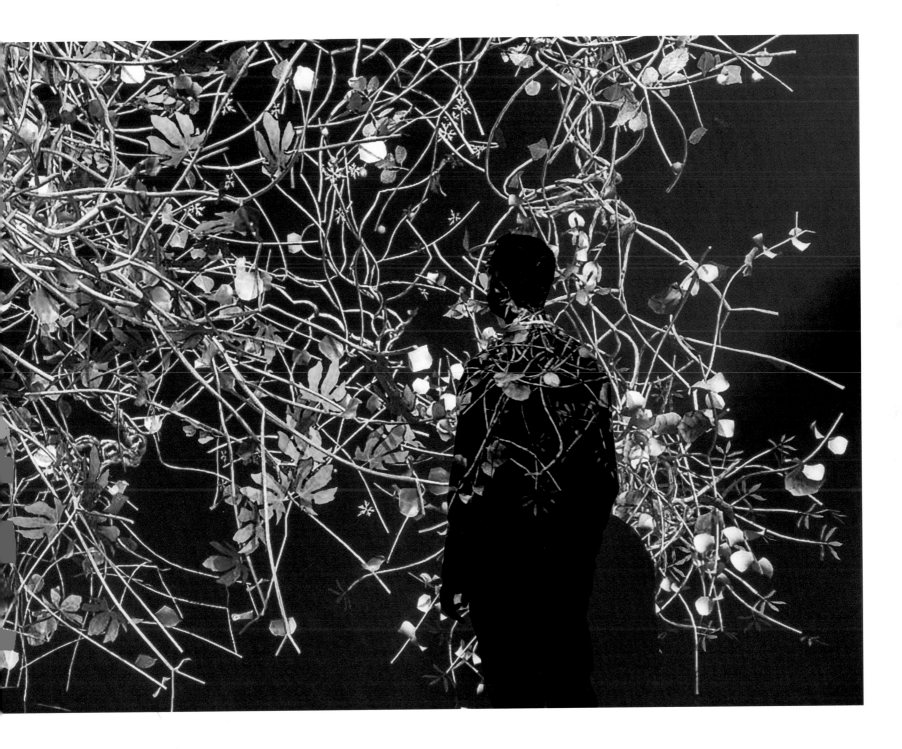

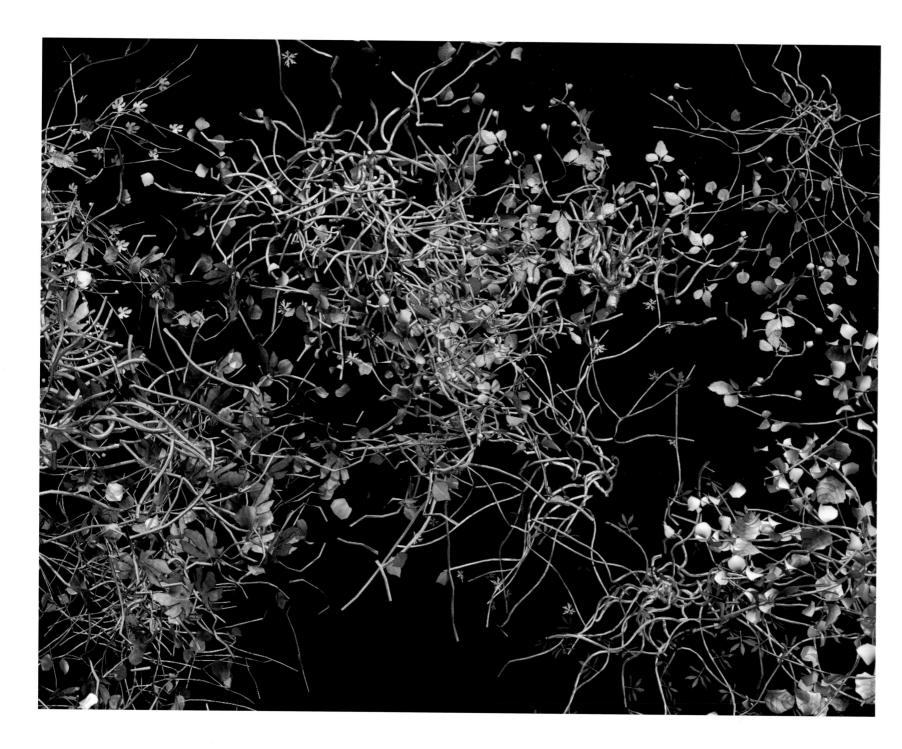

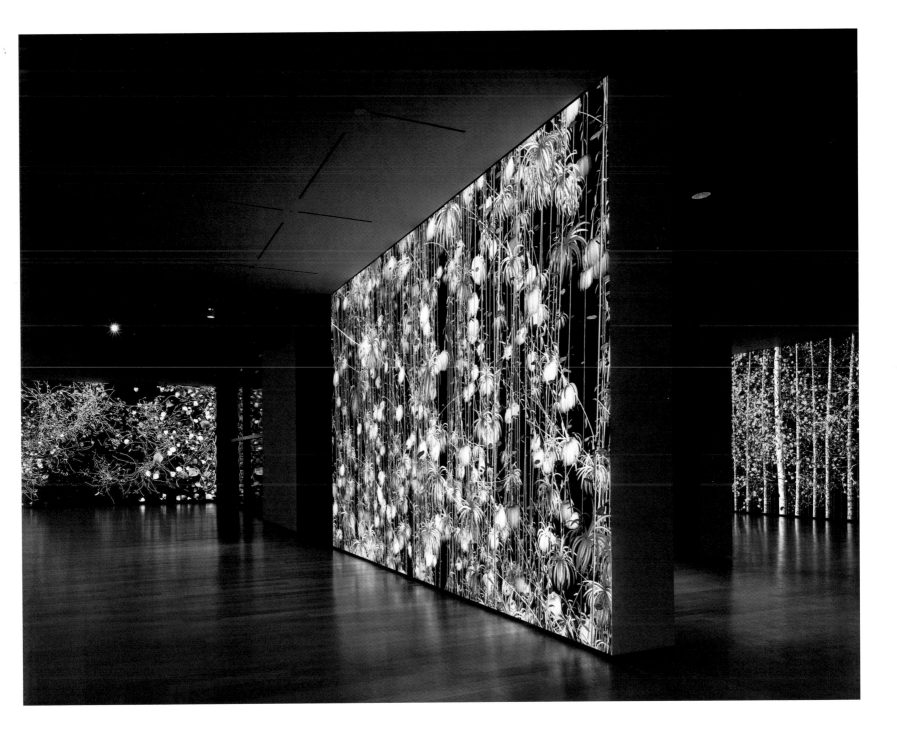

Blind Eye, 1

Blind Eye, 1, 2018
Video installation
12 ft. x 43 ft. 2 in. (3.66 x 13.16 m)

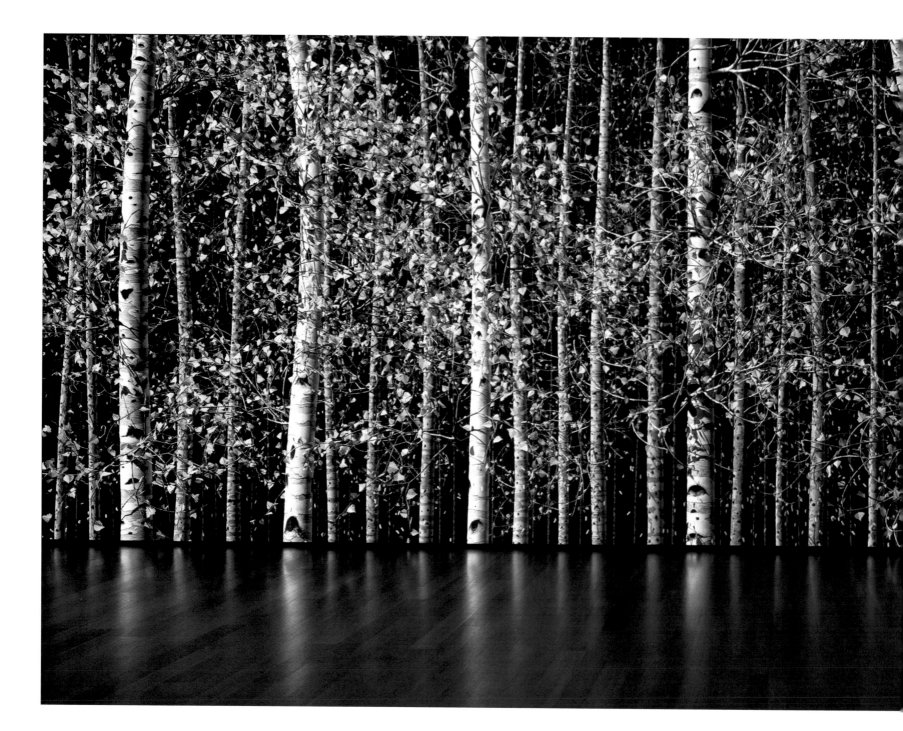

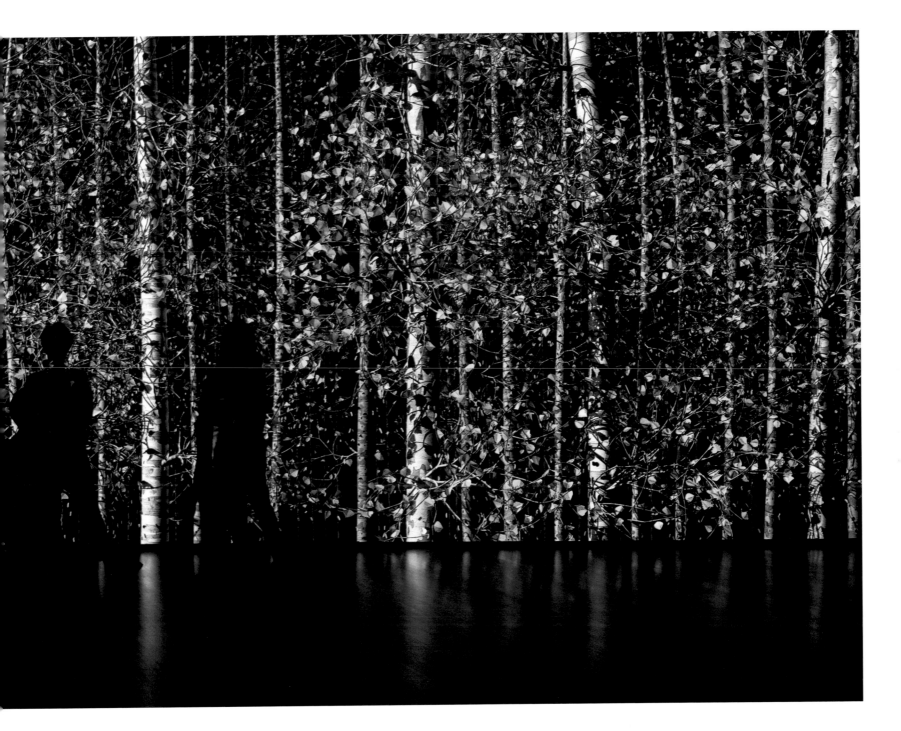

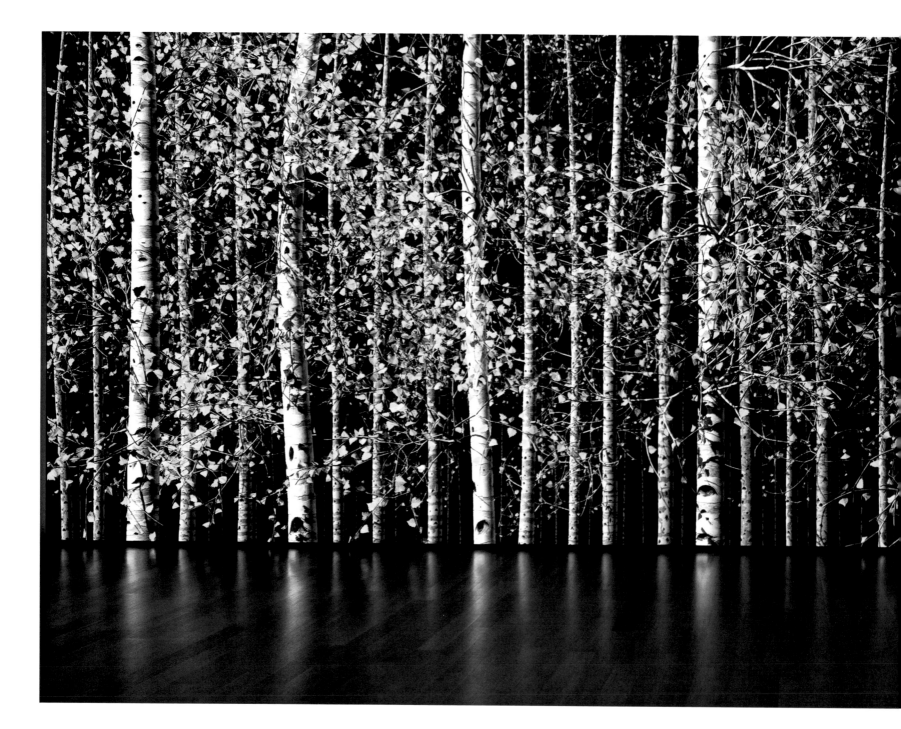

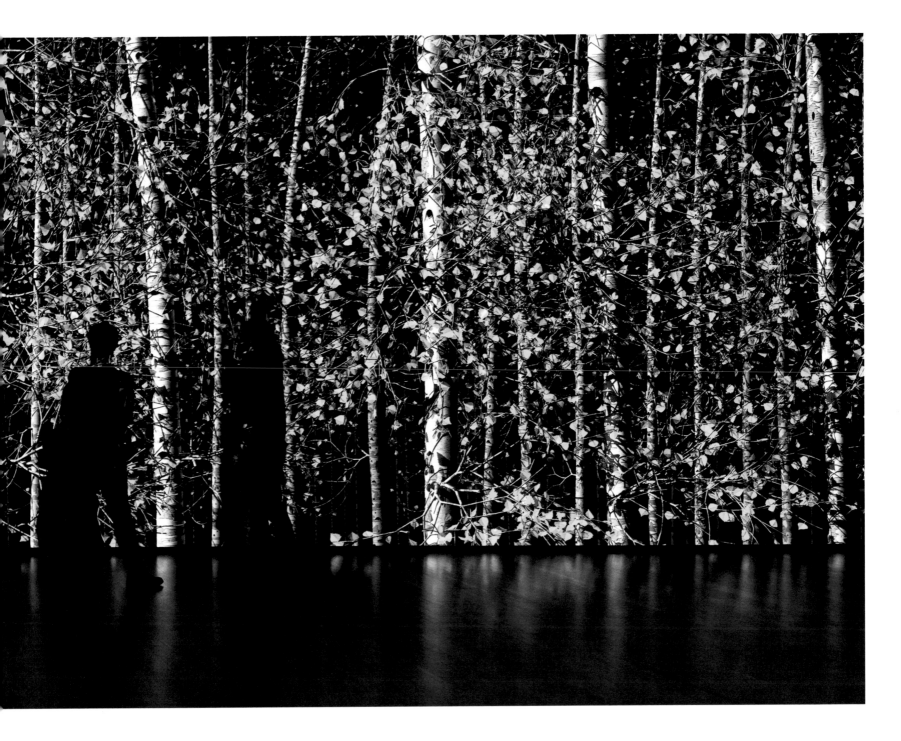

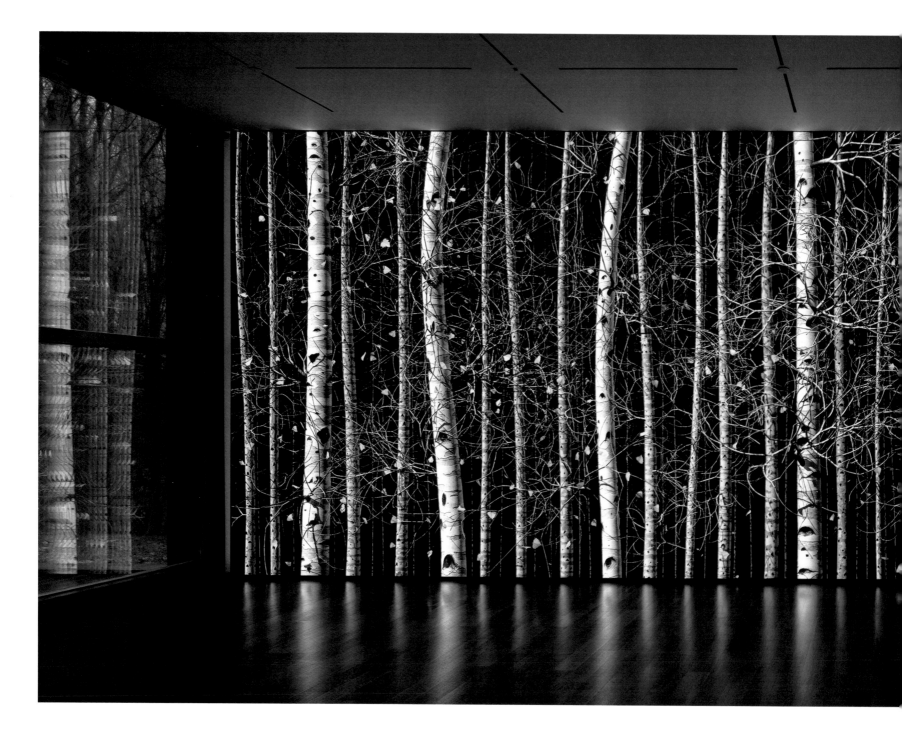

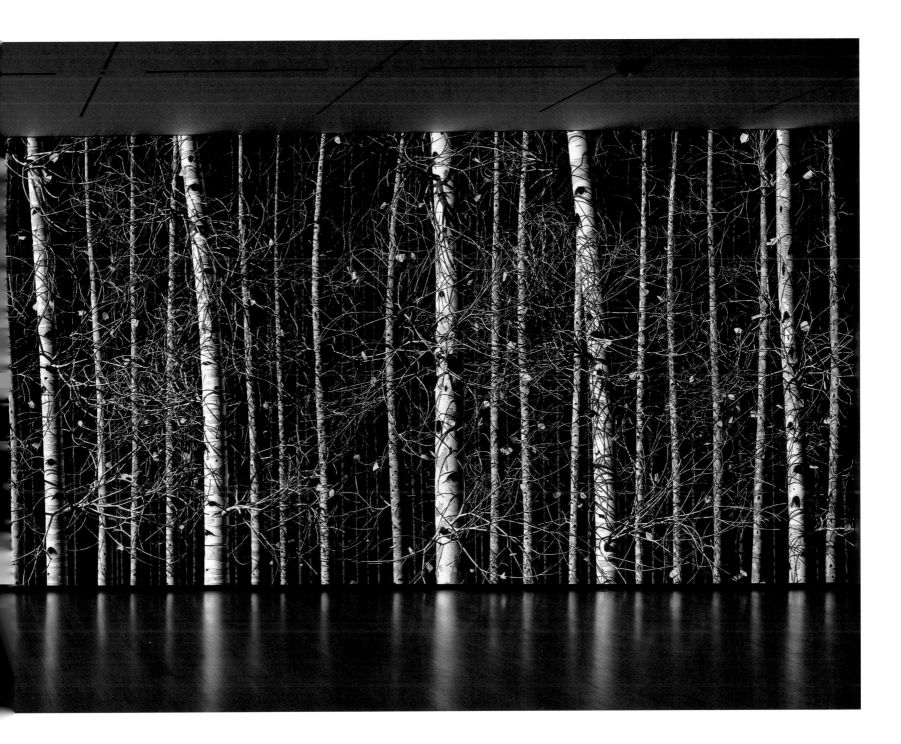

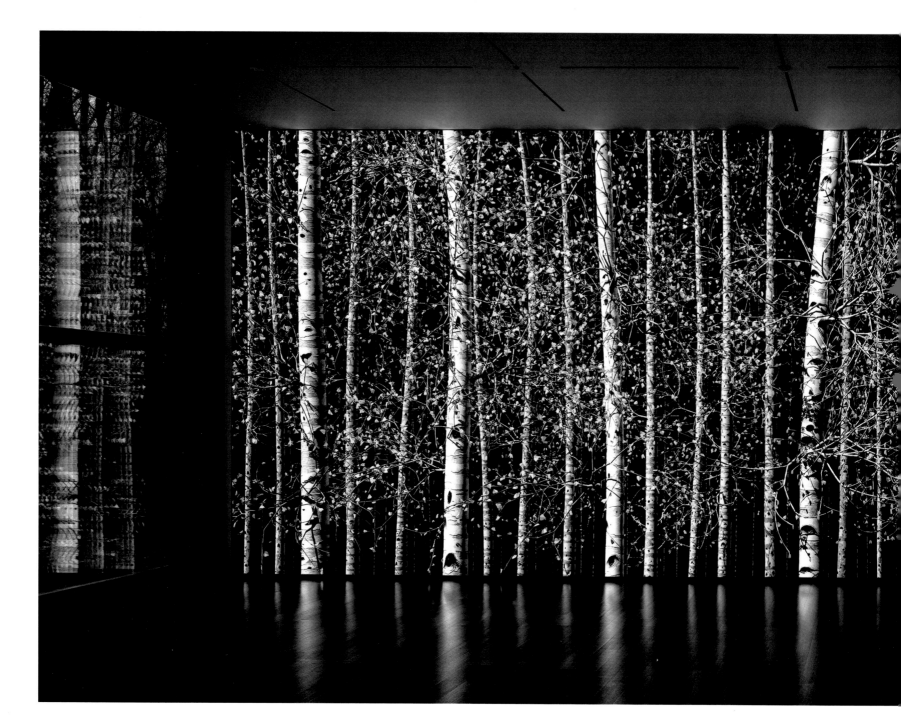

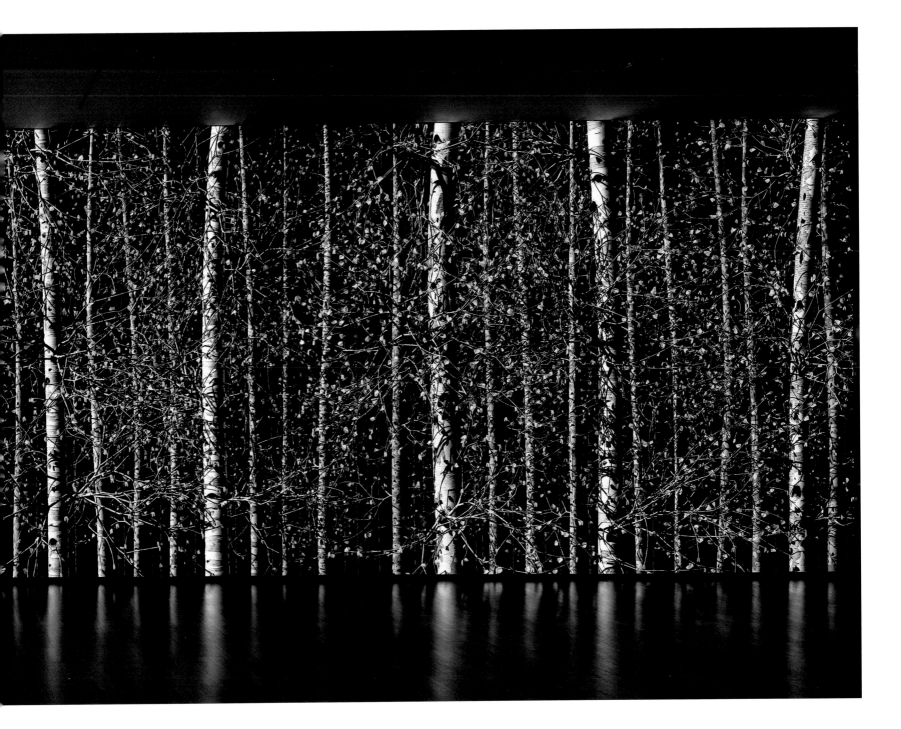

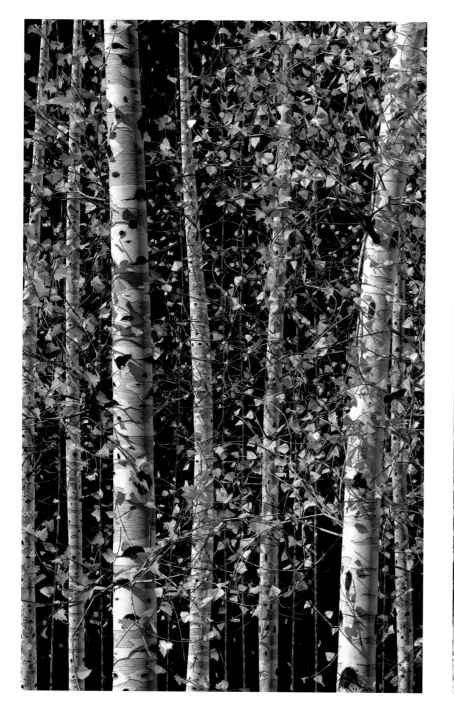
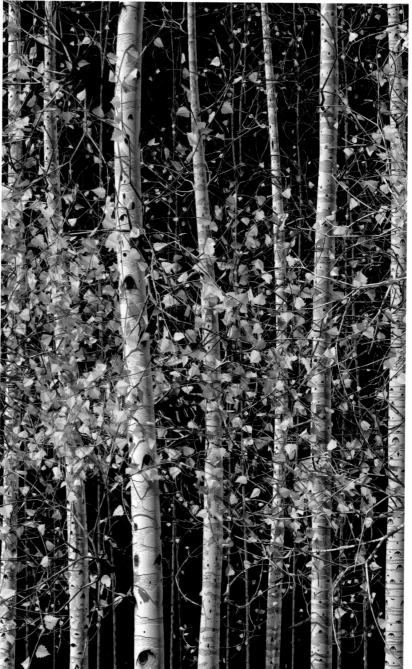

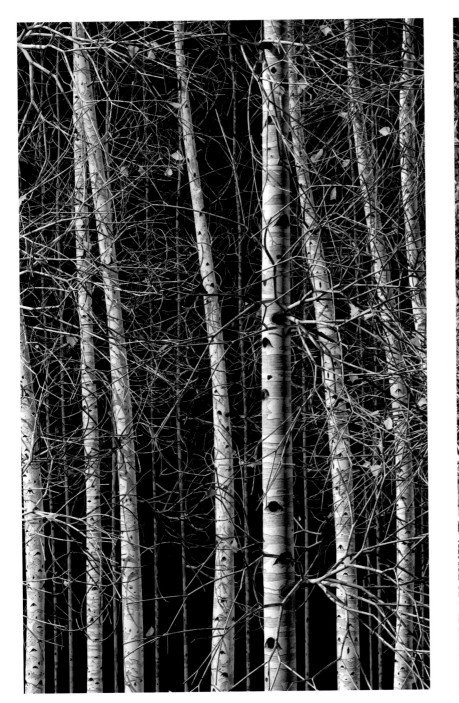
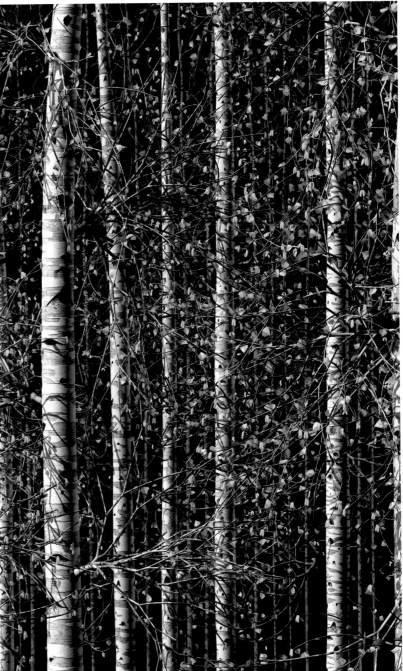

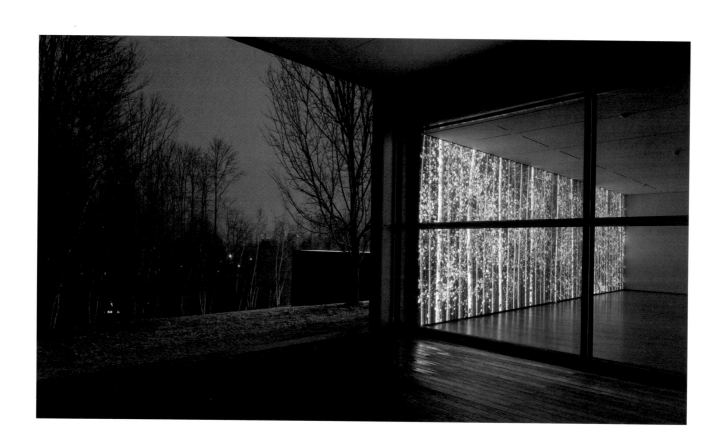

Exhibition Checklist

Jennifer Steinkamp
American, b. 1958

Premature, 6, 2010
Video installation
11 ft. x 5 ft. 9 in. (3.35 x 1.75 m)
(pp. 39–41)

Rapunzel, 5, 2005
Video installation
12 ft. x 18 ft. (3.66 x 5.49 m)
(pp. 43–47)

Fly to Mars, 6, 2006
Video installation
12 ft. x 14 ft. 10 in. (3.66 x 4.52 m)
(pp. 49–55)

Fly to Mars, 9, 2009
Video installation
11 ft. 2 in. x 8 ft. 2 in. (3.40 x 2.49 m)
(pp. 49–55)

Diaspore, 2, 2014
Video installation
12 ft. x 21 ft. 5 in. (3.66 x 6.27 m)
(pp. 57–63)

Blind Eye, 1, 2018
Video installation
12 ft. x 43 ft. 2 in. (3.66 x 13.16 m)
(pp. 65–75)

Jennifer Steinkamp

Jennifer Steinkamp employs computer animation and new media to create projection installations in order to explore ideas about architectural space, motion, and phenomenological perception. Her digitally animated works make use of the interplay between actual space and illusionistic space, thus creating environments in which the roles of the viewing subjects and the art objects become blurred. She completed her BFA and MFA from ArtCenter College of Design, Pasadena, California, in 1989 and 1991 respectively, and received an honorary PhD in 2011. Steinkamp has exhibited widely at prominent institutions and biennials worldwide, and her work can be found in numerous public and private collections, including the Chrysler Museum of Art, Norfolk, Virginia; Centro de Arte Contemporáneo de Málaga, Spain; Hammer Museum, Los Angeles; Istanbul Modern; Los Angeles County Museum of Art; Minneapolis Institute of Art; Museum of Contemporary Art, North Miami; and Museum of Fine Arts, Houston.

Lisa Saltzman

James Ewing

Lisa Saltzman is the Starr Director of the Research and Academic Program at the Clark Art Institute. Saltzman is the author of three books: *Daguerreotypes: Fugitive Subjects, Contemporary Objects* (University of Chicago Press, 2015); *Making Memory Matter: Strategies of Remembrance in Contemporary Art* (University of Chicago Press, 2006); and *Anselm Kiefer and Art after Auschwitz* (Cambridge University Press, 1999). In collaboration with Eric Rosenberg, she also organized and edited the volume *Trauma and Visuality in Modernity* (Dartmouth College Press/University Press of New England, 2006). Saltzman has earned a number of awards and academic honors, including fellowships from the Clark (2012–13), the Guggenheim Foundation (2012), and the Radcliffe Institute for Advanced Study (2002–3). Previously, Saltzman served for twenty-three years on the Bryn Mawr faculty, where she was chair of the Department of the History of Art and Andrew W. Mellon Foundation Chair in the Humanities. She also directed Bryn Mawr's Center for Visual Culture for seven years.

James Ewing is a photographic artist engaged in illustrating architecture, landscapes, art installations, and scale models. Common themes he explores are the history of modernism and the quest for utopia. Influenced by the tradition of architectural drawing, his works reference those of Hugh Ferriss, Ken Adams, and Frank Lloyd Wright. Prints of his images have been exhibited at the Van Alen Institute, New York; Cité de l'Architecture et du Patrimoine, Paris; and the Arthur Ross Architecture Gallery at GSAPP Columbia University, among others. His photography has received numerous grants and awards including a Fulbright grant, four American Photographic Artists awards, and a PDN World in Focus award. Ewing's architectural photography has been an integral contribution to numerous successful AIA Award submissions.

Published by the Clark Art Institute on the occasion of the exhibition *Jennifer Steinkamp: Blind Eye*, Clark Art Institute, Williamstown, Massachusetts, June 30–October 8, 2018

Generous contributors to *Jennifer Steinkamp: Blind Eye* include Maureen Fennessy Bousa and Edward P. Bousa and Amy and Charlie Scharf.

Produced by the Publications Department of the Clark Art Institute, 225 South Street, Williamstown, Massachusetts 01267
Anne Roecklein, Managing Editor
Kevin Bicknell, Assistant Editor and Rights Coordinator
Samantha Page, Publications Assistant
Anne-Solène Bayan, Publications Intern

Copyedited by Sharon Herson
Designed and typeset by David Edge Design
Proofread by Kara Pickman, Pickman Editorial
Printed and bound in the United States by the Studley Press, Dalton, Massachusetts

Distributed by Yale University Press
302 Temple Street
P.O. Box 209040
New Haven, Connecticut
06520-9040
yalebooks.com/art
10 9 8 7 6 5 4 3 2 1

Library of Congress Cataloguing-in-Publication Data
Names: Ewing, James (Photographer), photographer (expression) | Steinkamp, Jennifer, 1958– Works. Selections. | Saltzman, Lisa. Back to the garden. | Sterling and Francine Clark Art Institute, organizer, host institution.
Title: Jennifer Steinkamp : Blind eye / essay by Lisa Saltzman ; principal photography by James Ewing.
Description: Williamstown, Massachusetts : Clark Art Institute, 2018. | "Published by the Clark Art Institute on the occasion of the exhibition *Jennifer Steinkamp: Blind Eye*, presented at the Clark Art Institute from June 30 to October 8, 2018." | Includes bibliographical references and index.
Identifiers: LCCN 2018021337 | ISBN 9781935998358 (publisher: Clark Art Institute) | ISBN 9780300237054 (distributor: Yale University Press)
Subjects: LCSH: Steinkamp, Jennifer, 1958– —Exhibitions. | Projection art—Exhibitions. | Video art—Exhibitions.
Classification: LCC N6537.S712 A4 2018 | DDC 700.92—dc 3
LC record available at https://lccn.loc.gov/2018021337

Credits
Permission to reproduce images is provided courtesy of the owners listed in the captions. Unless otherwise noted, works by Jennifer Steinkamp are courtesy of the artist and Lehmann Maupin, New York and Hong Kong. Photography by James Ewing.

Additional credits are as follows:
Rendering by Jennifer Steinkamp, fig. 1b; photography by Jennifer Steinkamp, courtesy of ACME, Los Angeles, fig. 2; photography by Jennifer Steinkamp, courtesy of ACME, Los Angeles; greengrassi, London; and the Corcoran, Washington, DC, fig. 5; photography by Robert Wedemeyer, courtesy of ACME, Los Angeles, and greengrassi, London, figs. 6a–b; photography by Ed Restly, courtesy of the Estate of Eva Hesse and the Museum Wiesbaden, Germany, fig. 7; photography by Robert Wedemeyer, courtesy of ACME, Los Angeles, fig. 9; photography by Muammer Yanmaz and Robert Wedemeyer, courtesy of ACME, Los Angeles, and greengrassi, London, fig. 10; photography by Robert Wedemeyer, courtesy of Lehmann Maupin, New York and Hong Kong, figs. 11a–d; rendering by Jennifer Steinkamp, pp. 44–45, 62, 74–75

THE CLARK